DOMESTIC SCENES

Lawrence Weschler

THE
ART
OF
RAMIRO
GOMEZ

Afterword by
Cris Scorza

Abrams, New York

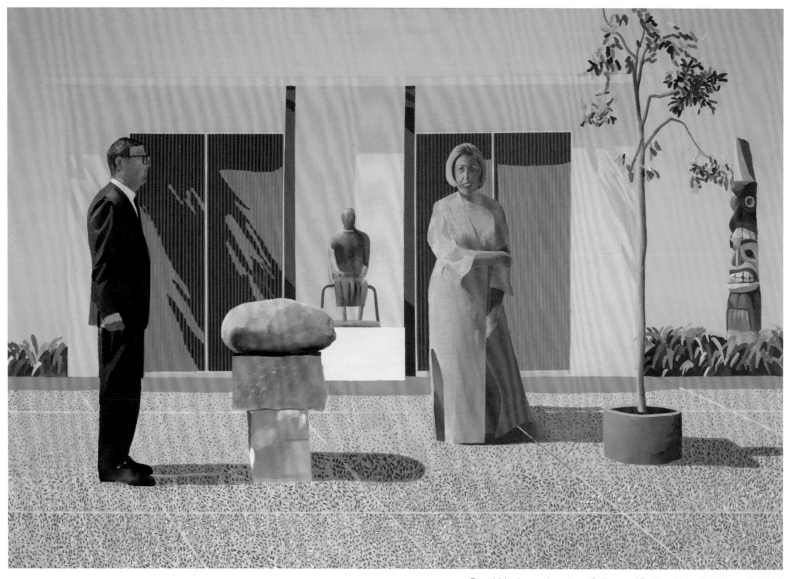

David Hockney, *American Collectors (Fred and Marcia Weisman)*, 1968

ONE AFTERNOON A WHILE BACK, in September 2014, I was in Chicago, taking in the masterpieces on a lazy walk through the new contemporary wing at the Art Institute—De Kooning's *Excavation*, the Cornell boxes, and a personal favorite, David Hockney's *American Collectors (Fred and Marcia Weisman)* from 1968 (with its incomparable California light streaming over the married couple, who are portrayed standing, clenched to either side, amid the trophies in their backyard sculpture garden, a picture that grows stranger and stranger the more you look at it, its coming as no surprise that the couple in question would presently divorce). Anyway, on my way out someone handed me a flyer for the Expo Chicago art fair, taking place concurrently out on Navy Pier, and so I meandered over there, made my way in, walked about, rounded a corner, and there on the outer wall of one of the booths directly ahead of me was exactly the same painting, same size, same palette, same light: David Hockney's *American Collectors* all over again.

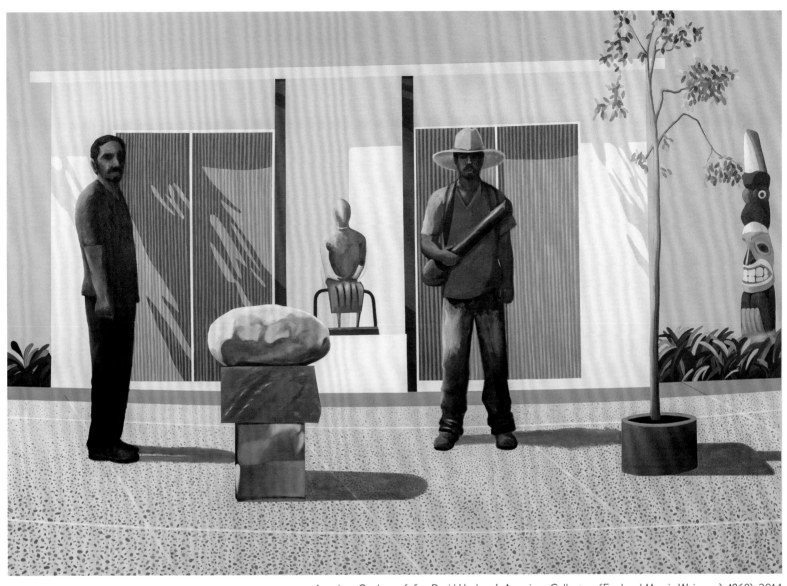

American Gardeners (after David Hockney's American Collectors (Fred and Marcia Weisman), 1968), 2014

Only: not. For in fact there were no collectors. Or rather, the collectors had been cannily replaced, at exactly the same location in the picture and at exactly the same scale, by two dark-skinned Latino gardeners, standing at attention, warily gazing out toward me, one of them with a leaf blower sashed across his chest. Nor was this the only Hockney pastiche in the booth. There was also, for example, a fresh take on Hockney's iconic WILSHIRE BLVD. street sign, only this time with a commuting nanny tarrying underneath, waiting for her bus (p. 48). And one of those supple Hollywood interiors, with its plump, high-design, blue-patterned sofa and the sleekly reflective black coffee table and the lipstick-red bouquet in the Chinese vase over to the side, and there in the middle of it all, a Latino housekeeper in blue jeans and a purple T-shirt, broom in hand, reviewing the tasks before her (p. 49). Further into the booth, there was one of those nondescript West L.A. apartment buildings with its wide front lawn, with a dark-skinned grounds keeper in the

foreground, rake extended (p. 41). Indeed that was the genius of the whole series: In much the same way that, back in the sixties, the English transplant Hockney had first opened our eyes to so much that we'd previously simply overlooked in Los Angeles, rendering all sorts of things visible to us as if for the first time (those boxy apartment buildings, the distinctive street signs, the Moderne furniture, *that light*), this artist seemed to be allowing us, indeed forcing us, to notice the very people who make that look, the look of L.A., possible, rendering visible a whole world of people, our fellow humans, who we ordinarily prefer not to see (who, for that matter, because sometimes "illegal," are often themselves striving not to be seen). The same with a print off to the side: a fresh riff on Hockney's signature poolside vista, *A Bigger Splash*, only in this instance the diving board jutting off from the side culminated in no splash at all—indeed, the piece was entitled *No Splash*, and smack in the middle, in the splash's place, over on the far side of the pool, one could make out the pool cleaner, poling for refuse, and off to the other side, another housekeeper, sweeping the terrace in front of the stylish low-slung home's sliding glass door (p. 35).

"RAMIRO GOMEZ" read the legend on the installation's wall, which also pegged the booth as belonging to the Charlie James Gallery in Los Angeles. Powerfully effective work, I remember thinking, though I also found myself wondering whether such Hockney-riffing wouldn't get old pretty quickly, if that were all there was. As if immediately to undercut such concerns, however, the booth's interior featured a grid of framed smaller pieces as well: torn-out pages of sleek ads and photo illustrations from the pages of *Architectural Digest* and *Vogue* and *Vanity Fair* and their like, hawking this lighting fixture or that kitchen cabinetry or that other dream family in their dream backyard, onto which

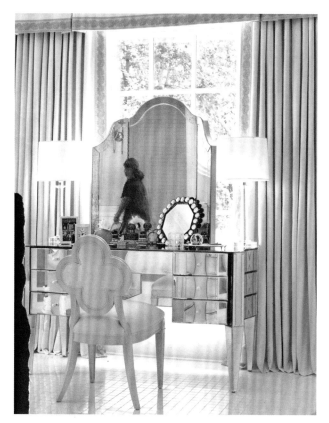

Perla's Reflection, 2014

the artist had meticulously painted—off to the side, in one case only barely reflected in a posh vanity mirror (above)—a nanny or housekeeper or gardener or handyman, faceless and self-effacing, almost though not quite to the point of invisibility (though, then again, emphatically not), the blur of paint on photo recapitulating the blur of status involved, the way the figures themselves both belonged and did not belong in the picture.

Strange, I found myself pondering (or rather, being invited to ponder), gazing on this succession of elegant picture-perfect layouts: Did the very shininess of their photographic representation in those glossy magazines enforce a regime of similarly flawless and antiseptic presentation in the actual homes of the owners those magazines catered to (much as Photoshopped female models enforce a crushingly impossible standard on the actual women who consume those images), an expectation in turn requiring this veritable army of near-invisible

The Domestic Idylls of Ramiro Gomez

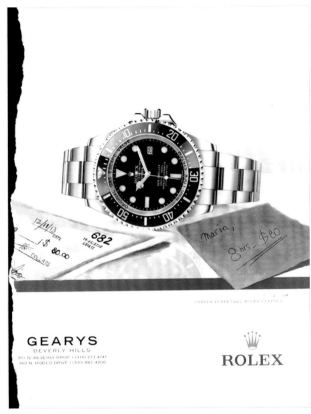

Maria's Paycheck, 2013

workers endlessly scrubbing and raking and polishing away, workers as individually disposable as the stuff they were being required to dispose of, who might in turn themselves come to introject that very sense of disposability, of replaceability, of worthlessness into their own senses of self? Questions of relative worthiness and value seemed at any rate to be at the very heart of Gomez's interventions: In yet another instance, he had taken an ad featuring a luxurious silver Rolex watch lying on a gleaming white surface and painted in, to one side, the corner of a blue check (made out to the sum of $80), and off to the other side, a pink Post-it note with the scribble, "Maria, 8 hrs = $80" (above).

At this point, as I was continuing to study the grid of magazine pages, the booth's overseer, the afore-mentioned Charlie James himself, loped over and introduced himself. A large fervent glad-handing enthusiast, James was only too happy to talk about his artist Gomez—"the Kid," as he repeatedly referred to him, endearingly, for Gomez, James now informed me, was only twenty-eight years old, born in San Bernardino, about seventy miles east of L.A., to at-the-time undocumented Mexican-born parents, his mother a school janitor and his father a trucker. From out of the local community college, Gomez had gotten a scholarship to CalArts, but somehow dissatisfied, he'd left there after a year and gone on to work as a nanny himself for a young "industry" family in the Hollywood Hills, leaving their employ after two and a half years to launch into what was fast proving a markedly successful career. The Hockney canvases had sold almost as quickly as the Kid could produce them—the first of them, the original full-size version of *No Splash*, had been snapped up from the front vitrine at the gallery's inaugural Gomez show in January 2014 by San Diego's Museum of Contemporary Art, before the exhibit had even opened. "The Kid's done about ten of them," James related, "but he says that that's it, he's not going to do anymore, the series has run its course and he has other fish to fry, which is too bad for me: I could have gone on selling those things for years, there was such incredible demand."

I mentioned that I was going to be out in L.A. a few months hence and asked if it might be possible to meet with the artist, and James assured me that that could be arranged.

WHICH IS HOW I CAME to be walking into the green-sward of West Hollywood Park, on the opposite side of San Vicente Boulevard from the gleam-ing Pacific Design Center, one afternoon a few months later, alongside the young artist, who'd ambled over to join me from the apartment a few blocks over that he shares with his longtime partner, David Feldman, a filmmaker and television editor. Jay, as he prefers to be called in conversation and has been since childhood (Ramiro Gomez *Junior*,

that is, to distinguish him from his father, Ramiro Senior), was a handsome, clean-cut, soft-spoken, achingly empathic young man, casually dressed in brown corduroy pants and a well-worn blue V-neck sweater pulled over a gray T-shirt. The air was brisk but the place was bustling.

"A beautiful day to be in the park," he was saying, "and of course it is a park, but it's also a workplace. Look around and you'll see: A good eighty percent of the adults in a place like this, as in most of the leafy green parks on this affluent west side of L.A. at this time of day, are in fact working—gardeners, grounds keepers, nannies—and a substantial portion of those are Latino. This particular park holds special significance for me, since it was the place I brought my own toddler twins most afternoons during the two and a half years I was working as a live-in nanny for their parents, up in the hills over there."

He went on to speak with considerable nuance about the dynamics of work in the park—how the makeup of the place tended to change with the passing hours; how especially here you could never be sure who was who (the young lady with the older father could as easily be his trophy wife as his housemaid, sometimes having started as the one to become the other; how more couples nowadays were interracial, which further upended easy identifications; and so forth); how most of the caregivers at this hour, though, were nannies and most of them were women (especially here in West Hollywood, where gay male couples tended to favor women nannies as a way of bringing a female presence into the family unit); how his being male had therefore proved quite a novel attraction for many of the kids there (and how much he in turn had learned from many of their women caregivers, who'd tended to take him under their wing); how so much of the innate child-handling talent on both his own and his fellow nannies' part had come from

the way they had themselves all been reared in wide extended families where everyone had had to care for everyone else all along ("My own nannies when I was growing up were my aunts and my grandmother, and I regularly babysat for my sisters and cousins"), families from whom many of these women had effectively been exiled for years as they endeavored to eke out an income to send back home. "But on the other hand," he went on, "that's also why so many families in a town like Hollywood have need of nannies, because this is a place to which all these aspiring people set out on their own, seeking their fortunes, leaving their own families far behind, such that when they in turn start having kids, they don't have aunts or grandmothers to call on, and they have to hire alternatives." He spoke of the love that these caregivers lavished on children not their own, while they themselves owned hardly anything, steeped all the while in a world of often conspicuous and overbrimming ownership. And of the strangeness of a situation in which one was thrust as a sort of public persona ("the nanny") into the most private inner sanctum of one's employers' lives, their very homes after all, privy to their most intimate secrets, treated at times almost as part of the family, though at other times decidedly not. You were expected to heap all this love on the children (and really, children being children, how could you help but do so?), and yet you could be dismissed on a moment's notice, on a whim, as others all around you were being all the time. Your fellow house help (the housekeeper, the gardener, the pool cleaner) could disappear from one week to the next, without so much as an explanation to them or to you (a specific way in which you were decidedly not part of the family). "Though there, too," he went on, "your situation was not all that different from that of your employers, especially here in this town, who were likewise expected to lavish all their

The Domestic Idylls of Ramiro Gomez

Nanny Sketch #7, 2013

passion on projects from which they too could be dismissed without cause at a moment's notice. All of which added to the blurring of lines, the strange intersectionalities one kept running up against."

And all of which he'd begun trying to deal with, he now explained, by way of a secret production he started undertaking, in his own room late at night after the family had gone to bed, or sometimes during the day during the twins' naptimes, as he began sketching out domestic scenes (above) and then tearing out pages from the design and lifestyle magazines the family had been throwing out and directly inserting his domestic workers. "In those early days, I still wasn't quite sure whether I was just a nanny with an artistic hobby, or an embryonic artist cocooned in my role as a nanny. It made me feel a bit like a spy, though, and I kept the images very much to myself. I never portrayed myself in them, but the women stood in for things I was feeling, noticed things I was noticing. They were always faceless—in part to suggest the way they were taken for granted and overlooked, but in part also because somehow the viewer read more into them that way; they were less threatening, more inner-directed, and as such they more readily called forth the viewer's empathy. But they were never

nameless: I always gave them names in the titles.

"For example, those over there," he said, pointing over at a mural gracing a retaining wall at the edge of the park that the city of West Hollywood had commissioned him to fashion only a few years after he'd given up his own nannying career, an homage to his fellow park workers. "The entire mural is called *Los Cuidadores* (*The Caretakers*). And that one there, the one holding the baby in the orange-stripe shirt, that's Daisy; the one next to her in the blue jacket holding onto the stroller, that's Elsa; and the other one on the bench, snuggling the standing child, that's Lucy. Those were the real names of the women that I had pose for me, my old colleagues" (below and pp. 56–57).

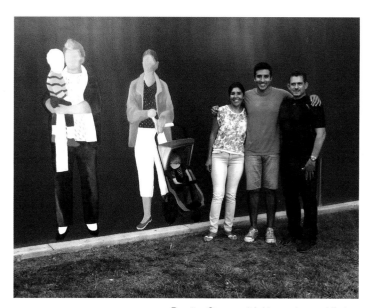

Ramiro Gomez with his mother and father in front of *Los Cuidadores* (*The Caretakers*)

AND WHAT ABOUT your own family? I now asked him as we took a seat on a picnic bench in the shade of a spreading tree, children marauding gleefully in the enclosure beyond under the watchful gaze of their various actual caregivers.

His parents, he responded, came from different parts of the countryside south of Guadalajara and west of Mexico City, though they didn't meet until after they'd both arrived, separately, in California.

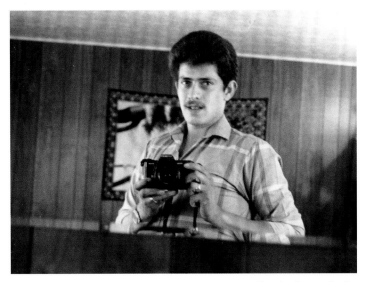
Ramiro Gomez Senior

His father, Ramiro Gomez Senior, the eldest of eight brothers and sisters from a modest, hardscrabble ranching family, set out on his own as a teenager around 1978, surmounting various adventures of passage before making it to San Bernardino, where friends from his home village had already secured him a job as a cook at a Sizzler Steakhouse; in the years that followed, he got another job at a nursery, where a mentor took him in hand and trained him to drive the long-haul delivery truck on regular runs to Las Vegas and back. (For over a decade now, he'd been working in a similar capacity for Costco.) Jay's mother, Maria Elena, by contrast the *youngest* of nine siblings, arrived in the United States in the mid-seventies, at age thirteen, with the better part of her family (though her father had died when she was only seven, murdered by a drunk). "The border was less militarized in those days," Jay explained, "so they did what many folks did, they secured phony papers with photos of people who looked vaguely like them, and my mother had to memorize the name of this person she was supposed to be, it was all quite tense as they approached the border, she was being drilled, 'Remember your name is so-and-so,' and she was bearing down, furiously trying to remember, but apparently it was late and

she'd fallen asleep, and they'd ended up getting through without any trouble, didn't even have to wake her, such that when they did finally rouse her, it was because they'd arrived at a McDonald's drive-through and wanted to know what she wanted to eat, and she came surging back to life, panic-stricken, stammering, 'My name is— my name is—' and she couldn't remember. That's how my mother recalls her traumatic arrival in America." They too settled in San Bernardino, where Maria Elena completed her secondary education and then proceeded from one job to another, in restaurants, lamp factories, onion factories, and the like.

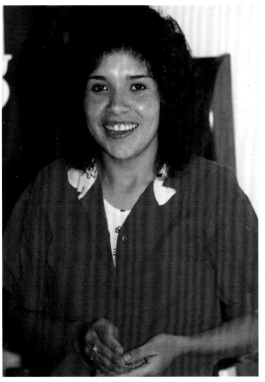
Maria Elena Gomez

Jay's mother and father met in 1981 ("My father," Jay explains, "is more Anglo-looking, more Spanish as they say, my mother more mestizo, and quite beautiful") and were wed in 1985, and Jay himself arrived the following year (the same year that his parents' undocumented situation was eased by Ronald Reagan's partial amnesty); two more children, both girls, would join the family in 1988 and 1994

(the latter being the year, as well, when Ramiro Senior and Maria Elena achieved full US citizenship).

His parents were both very hardworking, and the family was presently able to move into a modest tract home of their own in a mixed working-class neighborhood. "I never considered us poor, growing up, until a cousin one day told me that we were, because my mother used food stamps and we got free lunches at school," Jay says. "We didn't complain. When my mother had a little extra money, she'd let us know. A dinner at McDonald's was a great treat" (and would presumably come with extra-helping retellings of their mother's panic-stricken arrival in the country). Jay's earliest and fondest memories are of his mother's mother, his Nina, short for Madrina (for she'd also been his godmother; she'd baptized him and was the only grandparent he ever really knew, a wonderfully comforting and reassuring presence throughout), and of afternoons at her house, which he described as "a veritable summer camp," with him surrounded by bustling cousins, often off in the corner by himself steeped in fantasy play, drawing Power Ranger epics and the like, or out back, practicing soccer with a two-liter plastic Pepsi bottle for the ball and a sagging clothesline for the goal. (When he was six, his father's father back in Mexico had one day set off for the pharmacy to get medicine for his ailing wife and simply disappeared, never to be seen again, a catastrophe that cast an anxious pall over that side of the family for many years, with his father's mother dying shortly thereafter.)

Jay was a middling student at school—he didn't much like to read; he hated classroom assignments; he was good in English and social studies, bad in math; but from early on, he excelled in two areas. The first was art, so much so that a first grade teacher submitted one of his drawings to a contest, which it won, and he got to go see it hanging in a

I Love Futbol, 2004

Untitled, 2010

I Love My Dad, 2005

I Love My Mom, 2005

small local museum; *National Geographic* videos were his muse, he says, and his mother also encouraged and collected his artistic endeavors from early on. In high school, he won both divisions (the boys' and the girls') of a T-shirt design competition (submitting to the girls' division under a cousin's name), after which a sensitive teacher helped him craft an independent track focused on such artistic pursuits (p. 11).

But even more consuming, throughout his youth, was a passion for soccer, which he played with such panache and authority that he was steadily approaching near-professional caliber, except that—and he chokes up in the telling—there was a problem: He was a hemophiliac (a condition, passed down on the matrilineal side, that he would at times hold against his mother, angrily, broodingly, beyond all reason). It wasn't so much that he would get cut and bleed out; rather, he would get bashed and bleed internally, bruises that wouldn't heal, seepages that would wend their way painfully into his joints. He was regularly ending up in the hospital, sometimes for weeks on end (obliviously, he would pass the time drawing), where doctors would advise him to give up the sport; but as soon as he was out, he'd throw himself right back into the game, his only concession being an ever-more evasive running style, designed to avoid collisions, one that rendered him all the more formidable as a player—until, inevitably, it didn't.

The entire soccer passion, for its part, might also have compensated to some degree for another more unsettling aspect of his character, for since as long as he could remember, he'd been drawn to boys ("stealing a kiss all the way back in the sandbox, amid all the laughter and giggles, later on always wanting to hang out with the boys but hanging out with the girls instead"). Such tendencies were clearly frowned upon in his traditional Mexican family ("the uncles regularly ridiculing the extravagantly effeminate characters on the Mexican TV shows," his macho father scolding him "No no no" for playing out back with his sister's things), and for a long time he kept such hankerings hidden, wrapping himself in heavy metal T-shirts in junior high, pretending to his mom that he had girlfriends ("although I think she sensed things from early on and was always more understanding, more concerned for my safety, seeing it as something we would have to

The Domestic Idylls of Ramiro Gomez

get through somehow"). With the passing years, he grew increasingly anxious—the hankerings didn't seem to be something he could change—and he felt himself more and more like an outsider, an over-sensitive observer (qualities he associated with Van Gogh, to whose anguished imagery he was likewise increasingly drawn). Toward the end of high school,

I Love My Grandma, 2005

he went through an extravagantly goth phase, and when, on the eve of graduation, his father discovered photographs of him all decked out in mascara and lip gloss, "he just couldn't process that, he erupted in fury, and things between the two of us blew up completely, with everyone else screaming and crying, it was terrible." But it seemed to clear the air, and to some degree tensions subsided after that. A few years later, when Jay first met David and began regularly going downtown "just to hang out," the family gradually, fitfully, came to terms. His grandmother's love, meanwhile, was completely unconditional throughout, and enormously important. She was the only one who would take him aside

and just ask, like that, as if it were the simplest of matters, how things were going with David.

Jay paused for a moment, looking out over the park. "It's funny, though," he continued, "because I still feel like an outsider. I mean, David and I have lived together here in West Hollywood for several years now, but I don't feel completely at one with the whole gay scene here. I mean, after Proposition 8, the one where California gays momentarily lost the right to marry, there was that whole upsurge of righteously indignant demonstrations, and while I of course concurred with the frustration, I couldn't help but wonder where all these people had been when it came to the question of the rights of immigrants. Why was their own right to marry the only thing that mattered to them? On the other hand, I

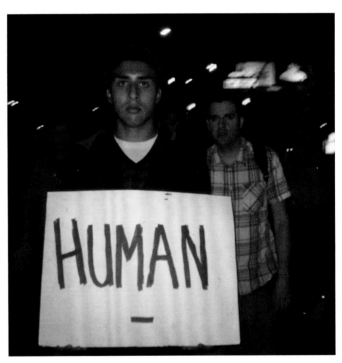

Gomez and Feldman demonstrating against Proposition 8

was not unaware that one of the main voting blocks that had pushed Proposition 8 through were the conservative Latinos, so I was as usual very much betwixt and between. I went home and found a blank placard upon which I scrawled out the single word 'Human' and returned to the march."

Lawrence Weschler

A FEW MINUTES LATER he was talking about David Hockney and an entirely other set of concerns rose to the fore. "Because I've been worried this whole time," he said, "that if he happened to hear about my pieces—and I know that some people have been trying to get him to see them, maybe even to comment on them—that he might think I was making fun of him or putting him down or something. And it's not like that at all. Hockney has long been a hero of mine, ever since I began to hear about him in high school and later in community college: the paintings, of course, which I loved, but especially the completely natural and forthright and uncomplicated way with which he dealt with his sexuality from the very start, both in his art and his life, which especially back in those days, a couple generations ago, was just so incredibly brave and trailblazing. The example of that authenticity had meant the world to me, a lonely lost kid out there in San Bernardino. My later pieces were never intended as send-ups of him; they're homages, and I just hope he would know that."

Well, I suggested, why don't we just go up to his place and see? As it happens, I myself have spent more than three decades interviewing and writing about Hockney, and in fact I'd been visiting with him a few days earlier and suggested I might want to bring over a young artist to meet him. (Steadily more and more deaf, Hockney has been cutting back on his social life considerably, but he still occasionally enjoys being visited by small groups in the quiet of his studio.) I called him on my cell, and sure enough he invited us up.

Jay was surprised but unfazed: He'd figured that such a meeting might well happen one day and he was actually happy in a way that it had not happened earlier; he now felt ready for it. We found my car and headed up Laurel Canyon into the Hollywood Hills, and then onto a series of side roads off the Mulholland crest, coursing past one swell

manse after another. Jay kept his iPhone cusped in his lap, and every once in a while (as when, for example, we passed a group of gardeners taking a lunch break on the back of a parked pickup, workers I was frankly embarrassed hardly to have noticed at

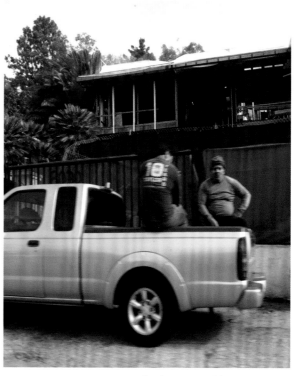

Gardeners near Mulholland Drive

all) he registered a quick snap, banking the image into his archive (above). "I know these streets almost by heart," he said, returning the phone to his lap, "from my own days as a nanny. And it's a funny part of town. This time of day it's almost entirely Latino, but come five o'clock, the pick-ups and the vans will all head back down and the limos and the sports convertibles will come cruising back up, and the demographics will flip over entirely."

We pulled up to Hockney's place, and David greeted us at the gate and escorted us into his studio. He was clearly in another one of his own prolific phases, having recently returned to L.A. following the better part of a decade spent back in Yorkshire, and he was taking stock of his friends here: Dozens of freshly painted portraits lined the

The Domestic Idylls of Ramiro Gomez

walls. The easels meanwhile featured plasma screens upon which he was projecting a series of massively Photoshopped group-portrait experiments: All sorts of individuals standing about in this same studio, each of them apparently prized at a different time (each individual in turn constructed out of dozens of details), in many cases the same individuals salted about in two or three different poses in two or three different spots around the image, the whole thing incredibly crisp and startlingly vivid: "Moving focus," David muttered, "as in Chinese scroll paintings, though as you can see I am also drawing on the perspectives in Cézanne and cubism."

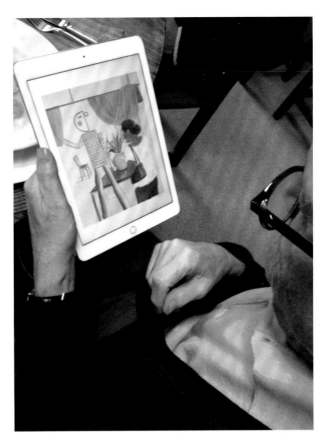

The thing that really leapt out at me, though, was the way that right there amid all the visiting dignitaries and collectors and friends and fellow artists and models were David's own two housekeepers, Patty and Doris, not by way of any sort of statement, but just because, as had always been the case, David simply portrayed whoever happened to be around and about at the present moment, his constant subject being his own lifeworld and those who made it possible. (I was reminded of several Polaroid photocollages, from back in the early eighties, of his housekeeper at the time, Elsa, and her entire family.)

One of David's assistants now called us over for tea, and David established himself in the infinitely sat-upon chair from which he often studies his paintings in progress at the end of a busy day. Jay sat down beside him, pulled out an iPad, and proceeded to walk him through some of his pastiches. Far from being offended, Hockney was if anything charmed and increasingly absorbed. He regaled us with stories of what it had been like for him when, almost the same age as Jay, he had himself been discovering L.A. for the first time. Stopping at one image in particular, a swath of bright green lawn across which Jay had inserted a Latino gardener pushing a big power mower (p. 45), Hockney noted

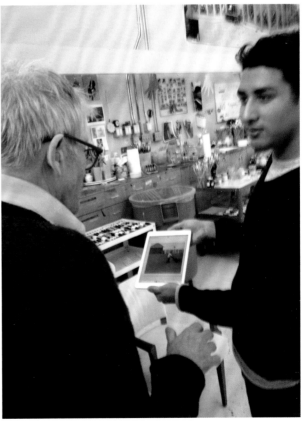

Gomez visiting with David Hockney

Lawrence Weschler

15

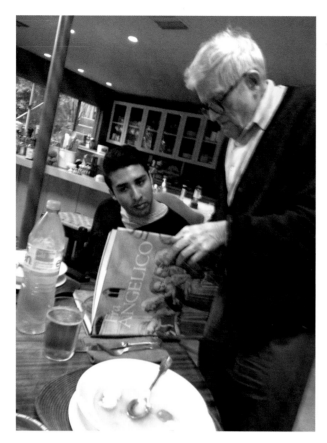

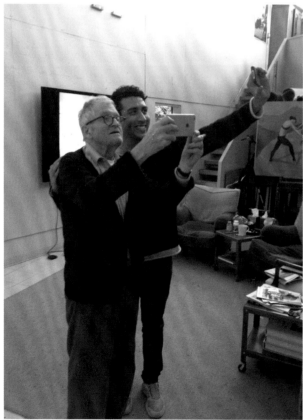

Gomez visiting with David Hockney

how the original image's subject had been the sprinklers ("I know," concurred Jay, "I know"); how coming from northern England, he'd never seen such a thing: "Amazing place," he recalled thinking, "where when it rains, it rains from the ground up!" Jay noted how nowadays when he sees a mown lawn or a cleaned floor, he can't help thinking of the people who mowed or cleaned them. Hockney smiled at Jay's version of his *American Collectors* and entertained us with tales of the evident tension between the couple at the time he was portraying them, and how it had just struck him as funny how much the wife looked like the stylized creature atop the totem pole off to the side. At one point, when Jay had risen to get a closer look at one of Hockney's recent portraits, David leaned over to me and whispered, "He's obviously very good, he knows exactly where to place the figures, and his color sense is spot on." Jay came back and showed us a suite he'd recently undertaken of postcards from the Los Angeles County Museum of Art onto which he'd painted images of custodial workers (pp. 112–115): trash collectors under the Heizer boulder or the Tony Smith polyhedral structure; and then, in front of a Hockney abstraction (a stylized standing stick figure pulling aside a curtain onto a still-life scene), a dark-skinned housekeeper on her day off, purse slung over her peasant blouse, studying the painting in absorbed, perhaps quizzical, silence (p. 15). "That was one of my early homages to cubism," said David. "I know," replied Jay. "And this card is *my* own way of engaging with *your* work."

Something about Jay's project put Hockney in mind of Fra Angelico, or maybe he'd just been thinking about Fra Angelico himself already, for he now reached for a nearby volume and presently the two of them were deep into its pages, comparing observations, celebrating details, lost together in the Old Masters.

The Domestic Idylls of Ramiro Gomez

Eventually it was time to leave, but David said, "Wait a second, take a picture of us!" I pulled out my iPhone and prepared to snap a shot when both of them simultaneously realized that they could use their own phones to snap a pair of selfies, which they proceeded to do, happily hamming, leaning into each other, and *that* ended up being the shot I got.

AS WE WALKED BACK to my car, Jay's cool momentarily deserted him (he'd clearly been quite moved by Hockney's kind solicitude and interest and validation), but steadying himself, he suggested that as long as we'd come this far we might as well continue over the hill to visit his studio in the flatlands on the other side. As we drove, he mentioned how envious his partner, David Feldman, was going to be, and that set him to talking about David and how they had first met, on an Internet date, and how incredibly well they'd hit it off from the start, which was a bit strange, David being over ten years his senior. Maybe it was because they both came from big families, a fact which mattered to them both, David being Jewish and from Philadelphia and one of those people who had had to leave family behind to some extent to seek his fortune in Hollywood as a film editor (who's regularly gotten work on such HBO series as *True Blood* and now *Getting On*). At first the age difference had bothered David, and for a long time he was hesitant to let Jay move in, but he'd been enormously supportive from the start, encouraging him, for instance, to push beyond his comfort zone and to leave home (from which he'd been attending community college) for the first time by accepting the partial scholarship he'd gotten to CalArts.

CalArts had proved a mixed bag: Jay appreciated some of his courses but bridled against the intensity of some of the critiques and in particular against the mandarin artspeak, the all-insistent theory verbiage from which he felt alienated (oddly

so, since so much of it was supposedly in support of minority and marginalized people like him)—he lasted a year but then dropped out. He drifted for a bit after that, from job to job; at one point he and David attempted a trip to Europe (David very much wanted to take Jay on a tour of his favorite museums), but Jay had had to cut the trip short when his beloved grandmother back home fell ill and died (his voice broke again at the memory). Some months after that he'd gotten the job nannying, which took up the next two and a half years, across which he began to focus in, via his secret production of magazine-based pieces, on the themes that would come to sustain him to the present day. Deciding to leave that job had been terribly fraught emotionally—he loved his charges and was well prized as it turned out by the entire family, who tried to convince him not to leave—but, again with David's support and encouragement, he'd come to feel that it was time for him to give himself over more fully to his art.

This was in September 2011, and in Los Angeles, graffiti was breaking out all over. Jeffrey Deitch was staging his big "Art in the Streets" show over at MOCA, Banksy was in town and on the loose, and for a while Jay toyed with the idea of joining that party. "But it turns out I am a terrible vandal," he confessed, laughing. "I tried, thinking I might spray-paint some of my domestic worker figures onto the sides of empty walls downtown. We even set out for a particular site, David and me late one night over on Spring Street, but it was hopeless: I just couldn't bring myself to deface people's property like that."

However, just around the same time, a friend of Jay's from CalArts, a performance artist/curator, was mounting a weekend of actions by a consortium of artists all up and down Sunset Boulevard, the twenty-mile avenue that wends from downtown L.A. to the ocean, and he asked if Jay might be interested in taking part. Jay asked whether

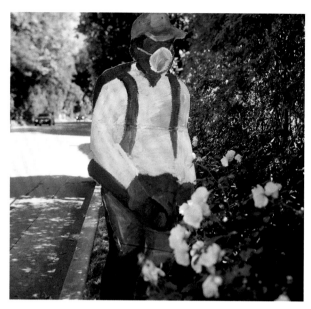

Gardener, Bel Air, 2012

anyone had claimed the section running through West Hollywood and Beverly Hills yet, and was surprised to hear not: Though then again, that whole stretch was all hedges and no walls. But hedges, it occurred to Jay, could be perfect.

He headed over to his local Best Buy, or rather the dumpsters behind the Best Buy, and rummaged about for the empty cardboard packagings of plasma-screen TVs and the like, took the cartons home, and began messing around (p. 55). "I love cardboard," he said. "I'd always loved the feel of the medium, its texture and its pliability. I'd been a huge fan of *Pee-wee's Playhouse* when I was a kid, and then more recently of Michel Gondry, the ways he deploys simple cardboard animations in his films. Cardboard felt more natural to me, more casual, less indulgent than canvas: more immediate." He took to painting his figures onto the cardboard, life-size or almost life-size, and then cutting out the painted figures— gardeners, raking and crouching and reaching and pruning: hedge workers!—and then he drove over to Sunset and leaned the painted figures against the hedges and amid the rosebushes (above). And the effect was uncanny. Leaning there against the greenery (or later, in subsequent incarnations,

against construction sites, bus stops, valet parking stands), they gave pause. "And that was the idea," Jay said. "I wanted to slow people down, to have them double take, to make them take notice and see. It was strange: Actual humans involved in their labor had become invisible to most people, but the *image* of a human, there, in the middle of your day, and not at some museum or gallery, but there in the middle of your path, somehow that registered. It provoked thought; it provoked recognition. And that's all I was going for."

The cardboard figures stayed up for as long as they stayed up: Sometimes, home or business owners would pull them down (or more strangely, order them pulled down, order their gardeners or hedge workers or valet parkers to take them down— and sometimes perhaps, or so Jay liked to think, the day workers did so and kept them); other times they stayed up for a while and weathered with time, disintegrating to tatters. Eventually, usually, they ended up back in dumpsters, and that too was fine by Jay, the disposability of the pieces being of their essence, calling attention to the unconscionable status of those they portrayed.

And people did begin to notice. There was a smattering of press coverage, particularly on blogs, where sightings were chronicled. Who was doing this? The following month, at a symposium at the Autry National Center in conjunction with its "Art Along the Hyphen: The Mexican-American Generation" show (part of that year's Pacific Standard Time cross-institutional extravaganza), Jay shyly approached one of the featured speakers, black studies professor George Lipsitz out of UC Santa Barbara, who was so impressed with what he saw that the month after that he spotlighted Gomez's interventions in a talk he gave at the Chicano Studies Research Center at UCLA. Seeing the steady rise in his friend's reputation, David (with whom Jay

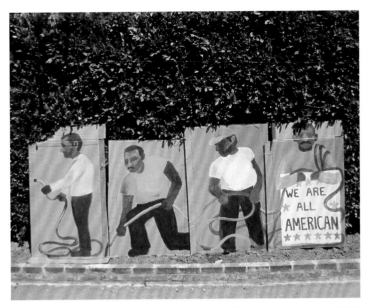

We Are All American, Clooney mansion, May 2012

had in the meantime moved in after all) offered to finance his art for a period, which in turn allowed the young artist to pour himself yet further into the work. He began appearing in video pieces on art sites. In May 2012, as the press gathered for a fund-raising appearance by President Obama at George Clooney's home in Studio City, Jay leaned a sequence of four cardboard gardeners against a hedge along the approach to the Clooney mansion, one of them holding up a sign reading WE ARE ALL AMERICAN, but the Secret Service was having none of it, requiring that the cardboard figures join the rest of the protesters cordoned off in an assigned "free speech" area well off to the side: The bored reporters of course ate it all up. By June, the *Los Angeles Times* was featuring Gomez in a stand-alone piece.

We'd arrived at Jay's studio—or anyway at what passed for his studio—on San Fernando Boulevard in the so-called Frogtown industrial district between Eagle Rock and Glendale, northwest of downtown L.A. The storage building had been converted into a warren of such artists' spaces, though Jay's was decidedly among the smaller ones, maybe the size of four or five closets (in the wake of his recent successes he was, he told me, looking to

expand). His paintings and magazine pieces were gone (most of them had recently sold), but there were several cardboard figures scattered around. He never sold those (that was a policy—if they survived he kept them): a woman in pants and a pink shirt, her mop in a bucket; an old lady in a red sweater walking along, her cane extended, lugging a plastic shopping bag; a warehouseman in blue overalls, a box of groceries slung over his shoulders. Most striking, now that I was able to see them in person, was the lived immediacy of their presence: the tired slope of their shoulders, the bend of their knees, the tilt of their heads, all of it conveying the weight of their experiences, the sag of their days.

Our own day had grown long, and we decided to pack it in. I drove Jay back home and we agreed we'd resume our conversation in a few weeks, when I'd be back in town and we could go visit his parents in San Bernardino on the eve of a big trip he was planning to Mexico City, where Charlie James was going to be featuring his latest work in a booth at Zona Maco, one of Latin America's premier contemporary art fairs.

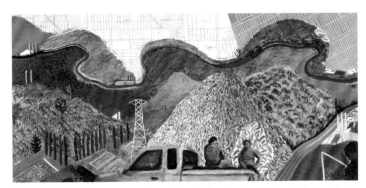

Mulholland Drive: On the Road to David's Studio (after David Hockney's *Mulholland Drive: The Road to the Studio*, 1980), 2015

Before that though, the next morning, in a sort of after-squib to the previous day, Jay e-mailed me the image of a thank-you gift he'd contrived that evening for David Hockney, a LACMA postcard of Hockney's wide, looping masterpiece *Mulholland Drive: The Road to the Studio*. In the foreground,

Lawrence Weschler

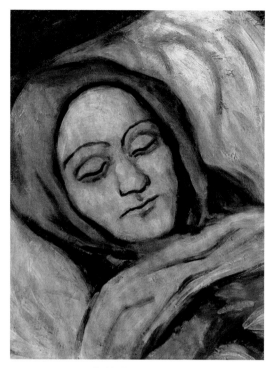

Pablo Picasso, *The Dead Woman*, 1903

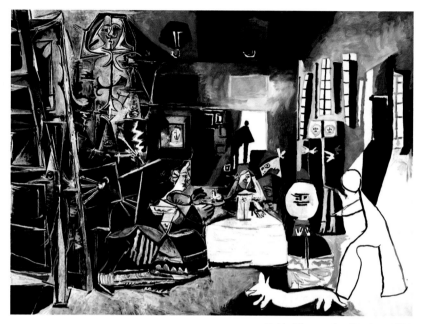

Pablo Picasso, *Las Meninas*, 1957

Pablo Picasso. *Humorous Composition: Portrait of
Jaume Sabartés and Esther Williams.* Cannes,
May 23, 1957 (grease pencil on magazine)

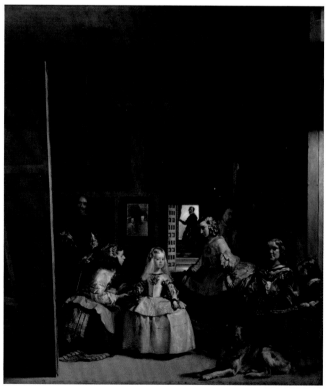

Diego Velázquez, *Las Meninas*, 1656

The Domestic Idylls of Ramiro Gomez

pitch-perfectly placed, were Jay's painted renditions of the gardeners we'd passed on the way up to Hockney's studio, lunch-breaking in the back of their pickup.

A FEW WEEKS LATER, on Super Bowl Sunday, as it happened, we were on the freeway out of L.A., heading due east, the length of the San Gabriel Range looming to our left, toward San Bernardino, Jay's partner David driving, Jay in the passenger seat, me in the back, and they were regaling me with stories of their early days, debating just how bad things had gotten regarding the problem of Jay's sexuality within his family (David suggesting worse than Jay was willing to recall), though they agreed things were much, much better now. And presently Jay was picking up where he'd left off, June 2012, which had begun with that *Los Angeles Times* piece and then culminated in a return trip to Europe, the resumption of the one he'd been forced to abandon when his Nina had died three years earlier.

They'd started in London, then Paris, but to hear Jay tell it, the trip proper had only really begun in Barcelona, at the Picasso Museum, where he'd been veritably flooded by one epiphany after another. To begin with, in a room given over to the young Picasso's Blue Period, the painting of a woman in her coffin, which for him held obvious associations; then, a special show of Picasso's work on magazines, of all things, another rich trove of convergences; and finally, a room devoted to showing how, later in his life, Picasso had engaged with his own master, Velázquez (opposite).

From there Jay and David had driven westward to Bilbao, arriving just before the Guggenheim there closed for a long weekend; as Jay raced past the huge Jeff Koons flowered puppy, he thought, Hmm, this would make a great place to lean a cardboard piece. But such fancies quickly evaporated once he got inside and found himself in the big touring Hockney retrospective, mainly his Yorkshire landscapes, which Jay had been reading about, but with the occasional outlier, such as the great *Pearblossom Highway* desert photocollage, "which really got to me," he said, "in part because I'd regularly driven that very highway and passed through that same intersection back in the days when I used to drive home from CalArts—but mainly because it helped me realize how, though Hockney's English paintings were obviously very beautiful, what really mattered to me, and I'd almost forgotten how much and how profoundly, was his L.A. work, which now hovered in the back of my mind throughout the rest of that trip and as it turned out, well beyond." From Bilbao, David and Jay traveled on to Madrid, first to the Reina Sofía, where Jay was bowled over by the *Guernica* (somehow all the more vividly wrenching thanks to his Barcelona preparation) and then the Prado, which as far as Jay was concerned, came down to one painting, before which he stood mesmerized for hours: *Las Meninas*. "The scale, the composition, everything," Jay explained, "but the thing that really got to me was how Velázquez, who could have painted anything—he was the principal court painter after all, the most revered artist in the country—chose to paint *that*, chose to portray *them*: the help, the princess surrounded by her nannies" (opposite).

Coming home, reenergized, Jay embarked on all sorts of new projects, three of which in particular bore the direct impress of his recent European sojourn. Channeling Picasso's intense political engagement at the time of the Spanish Civil War, Jay now turned to developments in the southwestern desert, especially in rabidly nativist Arizona, where hundreds of would-be immigrants were perishing of thirst and heatstroke on botched entry attempts every year. In response, Jay generated

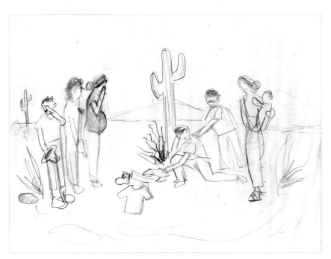

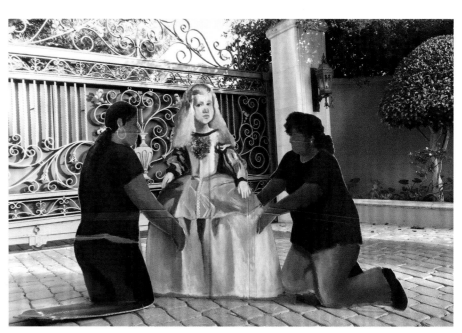

Sketch for *Los Olvidados* (*The Forgotten*), 2012

Las Meninas, Bel Air, 2013

a whole series of prepatory studies (above) and then fashioned his most ambitious cardboard figure combine yet—*Los Olvidados* (*The Forgotten*)—seven individually standing figures (eight if you included the baby cradled in one of the women's arms, nine if you counted the other baby still in another of the women's bellies), slumped in grief, grouped around a makeshift burial mound capped by an improvised stick crucifix, which was draped with a tattered sweater. David and Jay drove out into the Sonoran desert outside Tucson (David documenting the entire process for an eventual short documentary), navigated a series of side roads, parked, and then trekked a few hundred yards farther into the cactus-scrub wasteland, where Jay chose a site to erect his wrenching tableau (pp. 76–77). As Jay relates in David's moving (and subsequently multiple prize–winning) short documentary, the piece had special meaning for him: He'd modeled the skin tones and the body types and postures on members of his own family, and the passing of his beloved Nina lay very much on his mind the entire time he was working on it (any of those people, he said, could easily have been any of them, and either

of the babies him). And yet, curiously, the piece as such (as opposed to the film) misfires slightly (or it does for me anyway, one of the few times I've felt that way about Gomez's work): Perhaps it's being asked to bear too much weight; or else, maybe it's because its placement begs the question of just who it is being addressed to—the Arizonan nativists who might most benefit from its message aren't likely to come upon it out there in the scrabbly desert, and as for any lost or staggering inbound stragglers, just what might they be expected to make of it?

One of Jay's most successful cardboard improvisations appeared some months later, though, when he was invited to contribute to an "Art for the Cure" fund-raiser and responded with a life-size triptych: the Infanta from *Las Meninas* (beautifully realized, fully decked out in her seventeenth-century regalia) being tended to, to either side, by two contemporary Latina nannies (above). (The piece rang particularly true in the Beverly Hills of the fund-raiser, where six-year-olds routinely expect, and receive, such royal treatment.)

But Jay's greatest breakthrough, once again drawing directly on the afterglow of that European

The Domestic Idylls of Ramiro Gomez

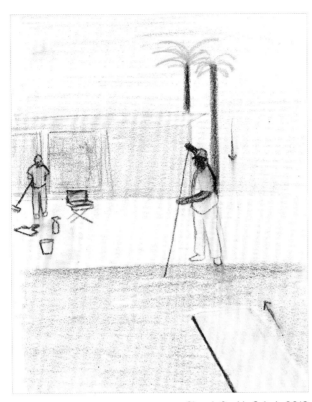

Sketch for *No Splash*, 2013

trip, came early the following year, 2013, when the Chicano Studies Research Center at UCLA offered him a one-man exhibition, entitled "Luxury, Interrupted," along the walls of its research library. Jay filled it with both magazine pieces and cardboard cut-outs, but there was one particular space, between two windows, that he was having a hard time working with. He was stuck for days and then it came to him (Velázquez to Picasso to Hockney), and he stayed up all night, blocking out and completing an initial study for *No Splash* (above).

"I was the first to see it the next morning," David now related, as we began to close in on San Bernardino, "and all I could say was 'Wow.'"

Indeed: For that little show and that piece in particular (p. 35) provoked an entire new boomlet of Web attention and a whole half-hour show on KCET, the local PBS station, which first brought Jay to the attention of Charlie James (a onetime senior manager with Microsoft up in Seattle who began collecting and then, in a bit of an early midlife crisis,

decided to pack it all in and reinvent himself as an art dealer in L.A.'s Chinatown, having no sooner done so than the bottom fell out of the market, in 2008, and yet he'd somehow managed to survive), and the two agreed to mount a full bore show at his gallery in early 2014. Meanwhile, Charlie took some of Jay's magazine work to a little art fair in San Diego, where three of those pieces were purchased by Hugh Davies, the highly regarded director of the Museum of Contemporary Art, and his education curator, Cris Scorza—Jay grew sniffly again as he related this part of the story, apologizing, "This is my mom crying"— which in turn gave Charlie occasion to show Davies photos of the *No Splash* study, informing him that Jay was busy preparing a full-scale version. Which is how it came to pass that Davies in turn made a preemptive purchase of that version of Gomez's seminal piece for his museum before the Charlie James Gallery show even opened on January 11, 2014: an auspicious start.

In the weeks just before the show, Jay had completed not just the scaled-up *No Splash* but four other 36 × 36-inch Hockney-based studies (the lawn being mown; a woman scrubbing a Beverly Hills shower; Nick's pool being cleaned; and the Beverly Hills housekeeper). In addition there was a whole array of magazine work. And the opening night was packed: friends, activists, academics, family, former colleagues. His former employers from his nanny days? "Actually no, though they do keep up with me on Facebook, and I think they are happy for me. In some ways, though, the most moving of all was Laticia: She'd been the housecleaner when I worked there. She'd come on Thursdays, as did the pool guy. That's them in *No Splash*. In fact, I was originally going to call that piece *Thursday Mornings*. But sometimes I would quietly show Laticia my magazine pieces, and she really loved them; in fact, she was clearly, obviously,

drawn to art, but when I asked her, she said she never went to museums or galleries, she felt like she didn't belong—and now here she was at a gallery, enjoying herself. Which was great: Because I don't only want to put domestic workers in my work; part of the work is to make them, the workers themselves, feel at home in the world of art."

WE'D ARRIVED IN SAN BERNARDINO—a town that has seen better times, one of those Southern California townships that keeps flirting with bankruptcy. Jay directed David on a wending little tour of his past life, through his old neighborhood (modest tract homes, tiny yards), past the old junior high (the same one his mother had attended and where she'd then janitored), and presently up and out of town, into the foothills of neighboring Highland, where the hardworking Gomez parents have been able to secure a considerably nicer, more spacious, and breeze-wafted home on the edge of town, on the flank of the towering San Gabriels, overlooking the San Manuel Indian Reservation with its casino. As we arrived, his mother and one of his sisters were in the kitchen, merrily rustling up food, his father out back tending the barbecue (everyone completely cordial and at ease with David, who'd clearly become a fully accepted part of the family). A steady stream of aunts and uncles and cousins drifted in. The football game was being teed up across an endless forced march of giddy preliminaries on the plasma-screen TV in the living room, but nobody was paying much attention, this clearly being mainly a brimming social occasion.

At one point, Jay pulled me outside. "I want to show you something." He went back to the car, opened the back, and pulled out a folded cardboard piece, and then walked over to a little patio alcove carved out of the front lawn, from which a shaded bench looked out over the flatlands below. "Toward the end, my Nina always used to sit here, just passing the time of day and . . ." He unfurled the cardboard cut-out: Now she could again. The piece folded at the waist and again at the knees, hands in its lap: a presence, revenant grace. We went back in to find Jay's mother, and I then remained on the inside, looking out through a window, as he took her out to see it. For a long time, the two of them stood there, leaning into each other, holding each other tight. Later, one by one, the others came out to see it (*her*) as well (opposite).

Presently, I went out back to join Jay's father at the grill as he turned the meats. He began telling me his own life story, starting with his youth on the family ranch back in Jalisco, and it came out in torrents. ("My mother is very much in touch with her feelings," Jay had once told me, "but she doesn't talk much; with my father, it's the opposite"—and I could see what he meant.) Not a detail was too minor to be omitted: every bend in his northern passage, the mechanics of the job at Sizzler, the early days at the nursery, a kindness by the nursery's owner, another by the trucker who took him under his wing—(Me: "And is that when you met your wife?" Him: "No, not yet")—what was involved with each run to Las Vegas, a little accident early on, confessing the accident to the owner and taking the blame, being (honesty appreciated) forgiven, and so forth. He seemed incapable of compression—just like his son, it occurred to me, who likewise had had to tell me about each and every Web notice, and every chance coincidence. And I gradually realized that this had nothing to do with egomania or self-obsession; rather, as perhaps with most first- and second-generation immigrants (and in a way that subsequent generations are perhaps spared), there had never been the slightest room for error, there was fresh amazement at every single turn in the story, had a single one not worked out as it did,

The Domestic Idylls of Ramiro Gomez

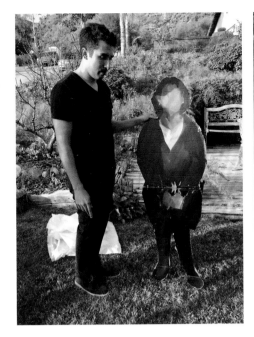
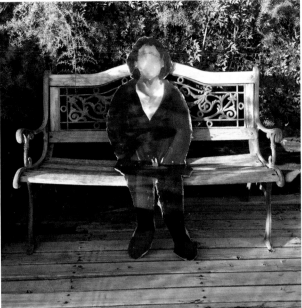

Gomez with his mother and *Nina*, San Bernardino

the entire project, this becoming an American, could have fallen by the wayside, all could have been for naught, such that every detail needed to be prized and accounted for.

We ate, we conversed, at one point Jay took me back to his Nina's old room, which was being preserved as it had been, though in the meantime it had also become a storage place for Jay's artwork going back to kindergarten (all of it carefully saved by his mother). On TV, the game was winding down though it was only toward the end that any of the aunts or uncles or cousins began to focus on it (it featured, as you may remember, quite an odd ending).

Folks began leaving, and as we prepared to take our own, Jay's father pulled him aside into the garage. He'd been hoping to accompany Jay the next day on the trip to Mexico City, but it turned out that responsibilities at work were going to prevent that. Still, he wanted Jay to listen to something. He rummaged about in a shoe box and pulled out a cassette tape and slotted it into a player. "A year after your grandfather disappeared," Jay's father now told him, recalling a moment almost twenty years past, "I arranged to have a DJ on a local Jalisco radio station he used to love to listen to dedicate a song to him on his birthday, in the hope that he might hear it and contact us." Whereupon he played the whole thing for us.

On the way back into town, Jay and David wondered what *that* had all been about—how maybe his father in some way was still hoping that perhaps this time *his* father, if he were somehow still alive, might catch word of his grandson's coming triumph, and, who knows, resurface?

IN THE END, of course, he didn't. (Who knows, of course, what ever became of so many of the disappeared in that so oft-cursed country, or for that matter of so many of the others who tried to escape: Los Olvidados.) But in almost every other way the trip to Mexico City still proved remarkably moving. I'd decided to tag along, as had David, and as, for that matter, had *David's* father, who joined us from Philadelphia.

From the first moments in the taxi taking us into town to the hotel Charlie James had reconnoitered for us, Jay was busy snapping away on his cell phone, constantly noticing window cleaners and

janitors and trash collectors, who for the rest of us otherwise simply seemed to blur into the passing scene, catching their momentary postures, banking the images, all in one clean gesture (up, click, down, glance, bank), and then gazing out and finding another. Occasionally though, in the days ahead, as we drove from one sight or venue to the next, Jay would grow quite overcome with emotion, tearing up, almost unable to continue, David reaching over to clutch his palm. In part, Jay confided at one point, he felt guilty at being the one getting such deluxe treatment when by all rights it should have been his incredibly hardworking parents who deserved it. But more often, it was the very nature of the treatment itself: "I can't help constantly feeling like I am on the wrong side of this window of privilege, driving around in cabs like this. How am I any different from those folks out there, who have to trudge about everywhere and never ever get to ride in taxis?"

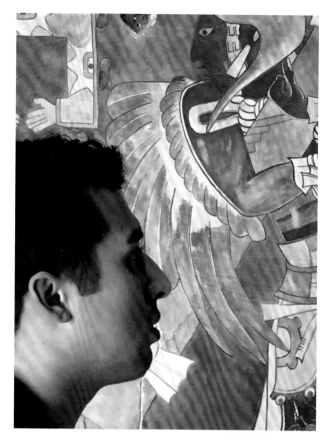

One morning we made our way over to the celebrated National Museum of Anthropology, where at every turn Jay seemed to be encountering profiles uncannily like his own, carved into stone, etched onto scrolls (right). He was deeply moved, as he told me, by "the everyday artisanal grace and beauty on display everywhere," but at the same time, especially in the Aztec pavilion, quite overwhelmed by the way that such momentary beneficences came steeped in a wider culture that celebrated the most harrowing warrior violence and human sacrifice—a veritable death cult set on a collision course with that other death cult represented by Cortés's arrival and symbolized, at the very end of the processional display, by a simple stark wooden cross. Jay's own existence of course tapped into both sources, such that the pavilion set off a virtual temper tantrum of emotional responses in him ("like that scene in *Chinatown*," he said, "with Faye Dunaway reeling, 'She's my sister,' *slap*, 'She's my daughter,' *slap*, 'my sister

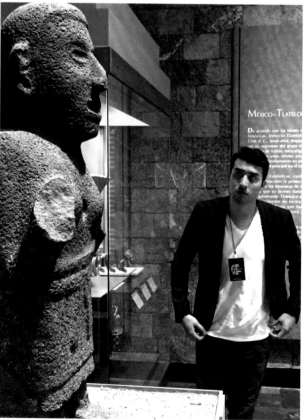

Gomez at the National Museum of Anthropology, Mexico City

The Domestic Idylls of Ramiro Gomez

my daughter my sis—'"). Both the glory and the gore from both sides constituting his multiple inheritances.

Later, in the Mayan pavilion, he came to a drop-jawed standstill before a video reenactment portraying two teams engaged in a fierce game of a sort of proto-soccer (he stood through the video twice), the players striking the heavy rubber ball almost exclusively with their hips, the other main difference from the modern sport being that in this game the losing team risked being slaughtered. At another point, a few minutes later, we listened in as a tour guide explained how the Mayan aristocracy was so inbred that hemophilia had become a terrible problem, an assertion that provoked a startled double take on Jay's part (his mother, the mestiza, turning out to be the one in the family whose roots may have wended back to royalty!).

But mainly Jay was in town to support Charlie James's booth at Zona Maco, which was principally featuring his magazine work, and I'd come along primarily because I was curious to see how that work would translate (I secretly suspected that the Mexican One Percent, which is to say its collecting class, might not cotton as readily as US collectors to Jay's depiction of Mexican-American life in the States: Not so nice, they might feel, and not so much what they necessarily wanted to spend their time pondering or identifying with).

The fair was taking place in the sprawling Centro Banamex (the convention center built by the venerable Mexican banking company which has, since 2001, been Citibank's Mexican subsidiary), slotted on a ridge between a bristling military encampment to one side and a lively horse-racing track down below to the other (as tart and pertinent a symbol of the position of capital in Mexico, perhaps, as one might wish to conjur). And in the event, I proved wrong in my original suspicion: Jay's work was proving as successful here as it had elsewhere.

Gomez with janitor, Zona Maco, Mexico City

But this was partly because such fairs, it turns out, are really playgrounds of an international collecting class (many of the main players drift from one such fair to the next, the far-flung stations of an annual social roundelay). Meanwhile, from among the many Mexicans who stopped to tarry in Charlie's booth, I was given to understand that exactly the same domestics-amid-wealth dynamic pertained here as well, only in Mexico it wasn't so much a question of foreign-pegged guest workers as one of laborers who were identified as more Mesoamerican in their origins, more dark-skinned and "primitive" than their (self-styled) European-bred masters.

But once again, it was Ramiro's relationship with the roving help that proved the most striking to observe. Or rather, if truth be told, it was almost only through Ramiro's steady gaze (and repeated instant photocaptures) that the help—for there were in fact dozens of trash pickers pushing gray wheeled garbage bins up and down the aisles—became visible at all. At any given moment there were probably four or five of them trudging along any particular aisle, spearing the stray gum wrappers and casually tossed brochures, palming this abandoned plastic champagne flute or that other half-pecked-at food platter (for, as Jay pointed out, "At

Janitor and sketch, Zona Maco, Mexico City

a place like this, the last thing people of wealth want to be confronted by is trash; appearance is everything, as with any other casino"), but all of them were so drably deferential and self-constrained that they seemed to disappear amid the wider spangly bustle. No one else seemed even to acknowledge their passage. Nor, for that matter, as Ramiro also noted, did they themselves ever seem to lift their hooded gazes to take in any of the art they were passing. Two worlds seemed to slide past each other, without any purchase, one upon the other. At one point Jay related how he'd been told that the laborers were getting minimum wage, which is to say four dollars a day.

"It's getting so difficult for me to process all this," Jay declared a few days in. "I'm positively itching to be painting." He himself now disappeared, reemerging a few hours later with a dark ballpoint ink silhouette of a particular janitor lady, one whom he'd photographed earlier as she trudged past Charlie's booth, penned onto the back of one of the Zona Maco map/guides (left). "I really should give it to her," he said, whereupon we two headed off to find her, up one aisle and down the next, but she was nowhere to be found. Funny how when you're looking for one particular dark-uniformed individual, every other such dark-uniformed individual momentarily seems to be the one in question, and then is not. Finally, there she was, up ahead two aisles, sliding past. We rushed up to the corner, but once again she'd completely disappeared.

EARLIER IN THE DAY, Jay and David and I had taken a break from the fair to visit a widely heralded new cutting-edge contemporary art space on the other side of town—a Mexico City version, we were told, of the old Dia Art Foundation on West 22nd Street in New York called Jumex, improbably sponsored by the foundation of a beverage conglomerate with

The Domestic Idylls of Ramiro Gomez

the same name—and it had indeed proved a bracing experience. A clean, precise building, well lit, painstakingly curated, every floor given over to a different international artist, with much of the work quite rigorously challenging. One floor, as it happened, was featuring *The Autoconstrucción Suites*, the ongoing project of a midcareer Mexico City artist named Abraham Cruzvillegas (b. 1968), who sought, in the words of the wall panels, "to root his sculptural practice within the urban landscape of his childhood home in Ajusco, a district in the south of Mexico City where structures remain in a constant state of transformation as additions are made when materials become available and necessity dictates." Which is to say it was a pretty chaotic jumble, planks and boards and bricks and sand in pell-mell piles here and there, and then, around the edges, all manner of posters and postcards and books, "expressive signs from everywhere I go," according to an artist's statement, "much like Aby Warburg's *Mnemosyne Atlas*, like a silent soundtrack of time and space." Godard, Adorno, Deleuze, wrestlers, Che, beer ads: the whole postmodern works. All of which was fine as far as it went—the trouble (for me) being that this sort of art-school-mediated, arch-critique-driven work goes very far indeed these days: signs and signifiers and high theory strewn all about, mediated by way of the humblest (and often least attractive) materials ranged about in seemingly haphazard combines, daring us (let alone any actual urban dwellers who might happen to wander by) to make heads or tails of any of it.

Not that I mean to pick on Cruzvillegas in particular: His is merely one instance (and far from the most problematic) of a trend one finds all about the high-flying, high-stakes art world these days. "Art is a conspiracy between artists and rich people," one of Kurt Vonnegut's characters once opined, "to make poor people feel stupid." These days, it some-

times feels like art is a conspiracy between artists and dealers and cognoscenti and the otherwise art-school indoctrinated to make the rest of us feel clueless. Which in turn was one of the things I'd found so refreshing in Ramiro Gomez's work: the direct immediacy of its address. "An intellectual says a simple thing in a hard way," Charles Bukowski famously declared. "An artist says a hard thing in a simple way." And though decidedly not pitched principally to intellectuals or theorists, Gomez's work often plumbs profound depths beyond its simple placid surfaces. "The purpose of art," said James Baldwin, "is to lay bare the questions that have been hidden by the answers."

And Jay's work surfaces all sorts of questions, some of them quite vexing. For, as I often found myself wondering, what exactly did these collectors imagine they were buying when they acquired one of his pieces and brought it home, usually to a place where, chances were, it was going to end up being dusted and cleaned by exactly the sorts of domestic workers depicted within the image? Not that Jay was the first artist to depict the working help: think of Velázquez, or Chardin, or Millet. But such work usually partook of the sort of thing the literary critic William Empson, back in the thirties, anatomized as "versions of the pastoral," work by members of one class, that is, directed to members of the same class, knowingly played out against the backdrop and in a stylized version of the idiom of a lower class (Elizabethan idylls, the ancien régime vogue for daintily dressing up as shepherds and shepherdesses—Empson even includes Lewis Carroll's Alice stories under this rubric). Van Gogh in his early years was perhaps closer to what Jay has been up to (and what would *he* have made of the stratospheric prices some of those dark peasant oils of his have lately been fetching?). But such class dynamics, in Empsonian terms, were completely upended in Gomez's work.

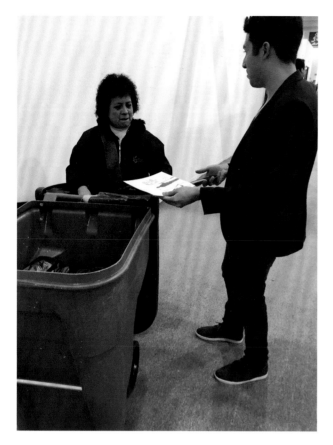

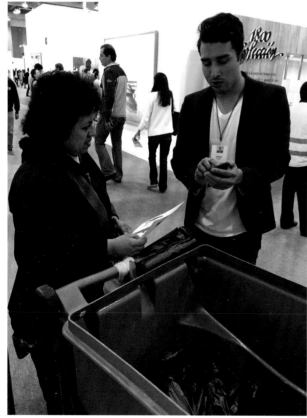

Gomez with janitor, Zona Maco, Mexico City

Still, at one point I asked Jay whether he was bothered by any possible dissonances in the acquisitional fate of his pieces (I knew, I'd seen, how he was clearly troubled by the changes in his own life status that their success was fomenting). But, "No," he replied, "not really. I mean," he continued, "it's the whole point of this project to give people pause, to get people to stop, if only for a moment, and think. As for the collectors, or for that matter people who might come upon the outdoor cardboard pieces in the midst of their daily routines: If you throw a rock at someone, they're just going to get angry and throw it right back at you. You have to approach them softly, quietly, at an angle, if you expect to get through and provoke that moment of recognition. More to the point, though, this work isn't only aimed at the collectors. It's aimed every bit as much at the workers. I want to give them pause too, to let them know, in the midst of their daily rounds, that they too are recognized and *worthy of being recognized*."

SHE WASN'T THERE, or there, and then suddenly there she was! Right behind us. (How had she pulled that off?)

Jay approached her quietly, respectfully. Middle-aged, stout, with dark curly hair, she was barely taller than the trash bin she was hauling about. "Excuse me." She looked up, startled, wary: Had she done something wrong? Jay explained how he was an artist, he had some of his work up in that booth over there, and he'd seen her passing and he'd drawn her picture and he wanted her to have it.

He handed her the silhouette.

She was still wary, and even a little anxious. People were stopping to look (she'd become momentarily, perhaps dangerously, visible), guards off in the corner were eyeing the situation. But she held the drawing and paused—one second, two seconds, three—and a small private smile now spread across her face.

30

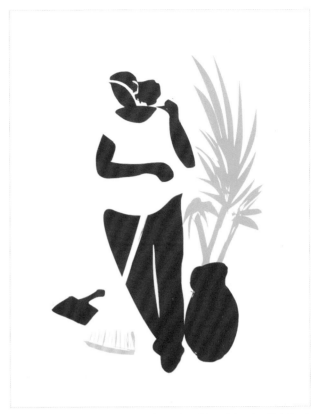

Azul, 2015 (digital drawing/lightbox)

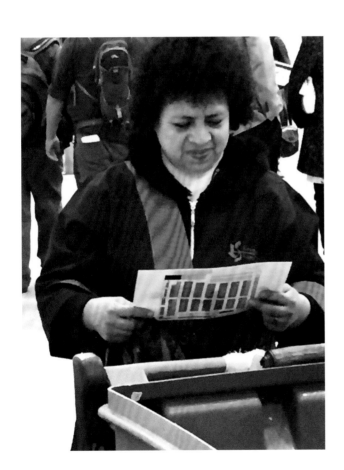

Works

After Hockney

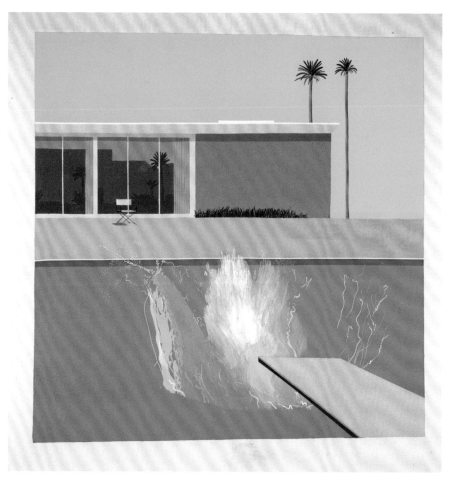

David Hockney, *A Bigger Splash*, 1967

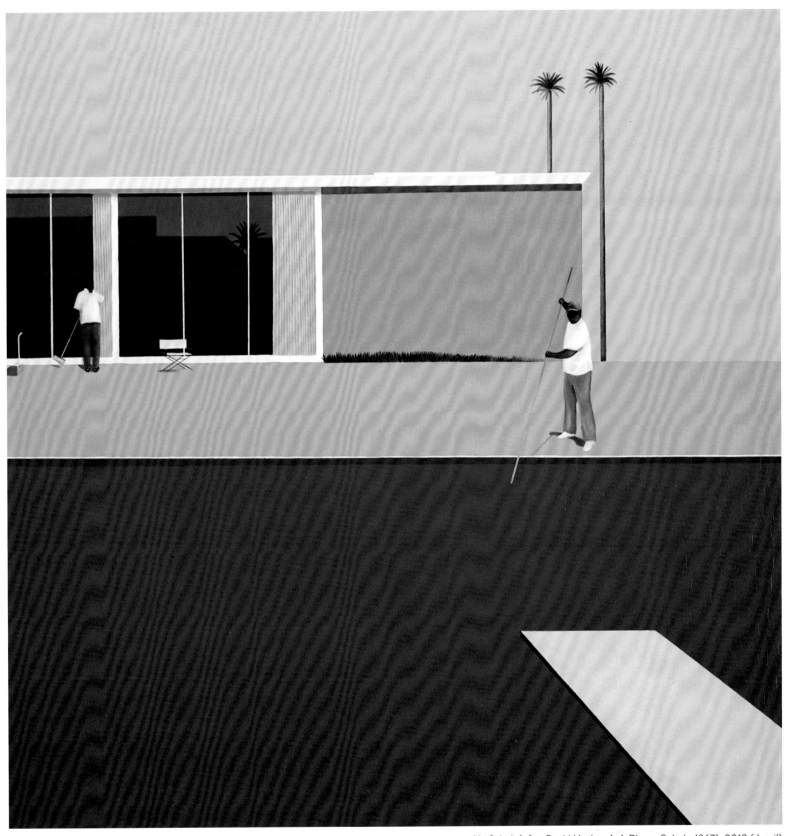

No Splash (after David Hockney's A Bigger Splash, 1967), 2013 (detail)

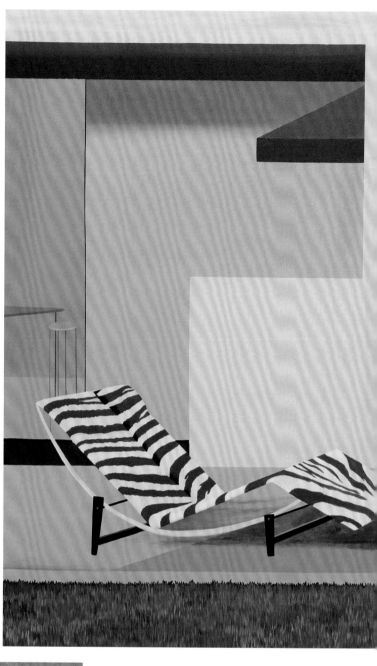

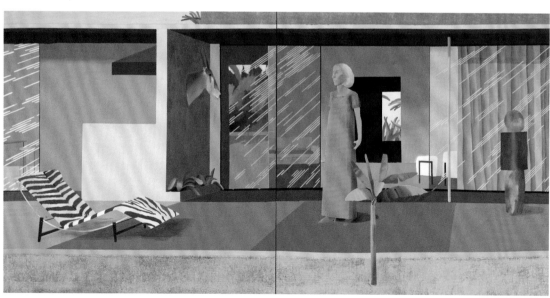

David Hockney, *Beverly Hills Housewife*, 1966–1967

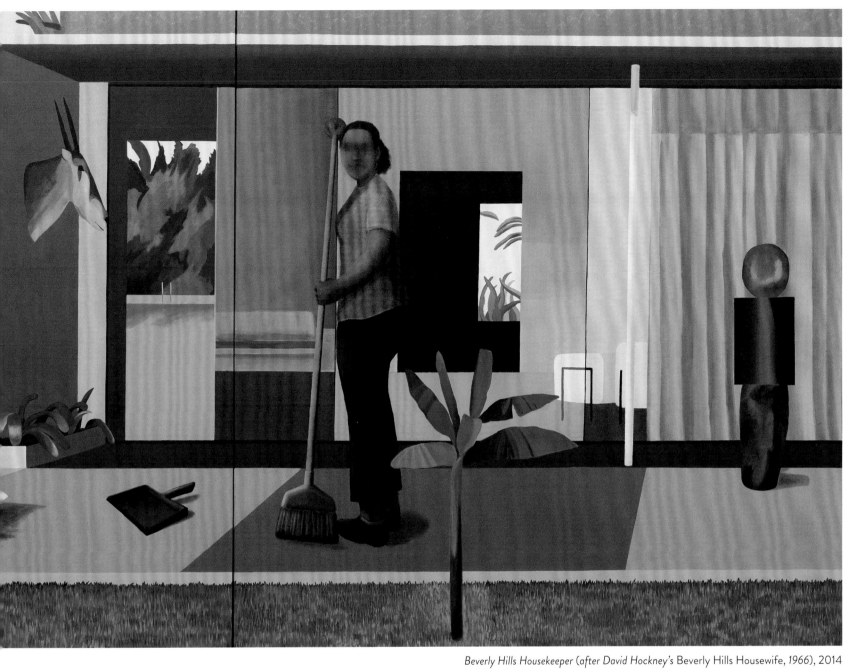

Beverly Hills Housekeeper (after David Hockney's Beverly Hills Housewife, 1966), 2014

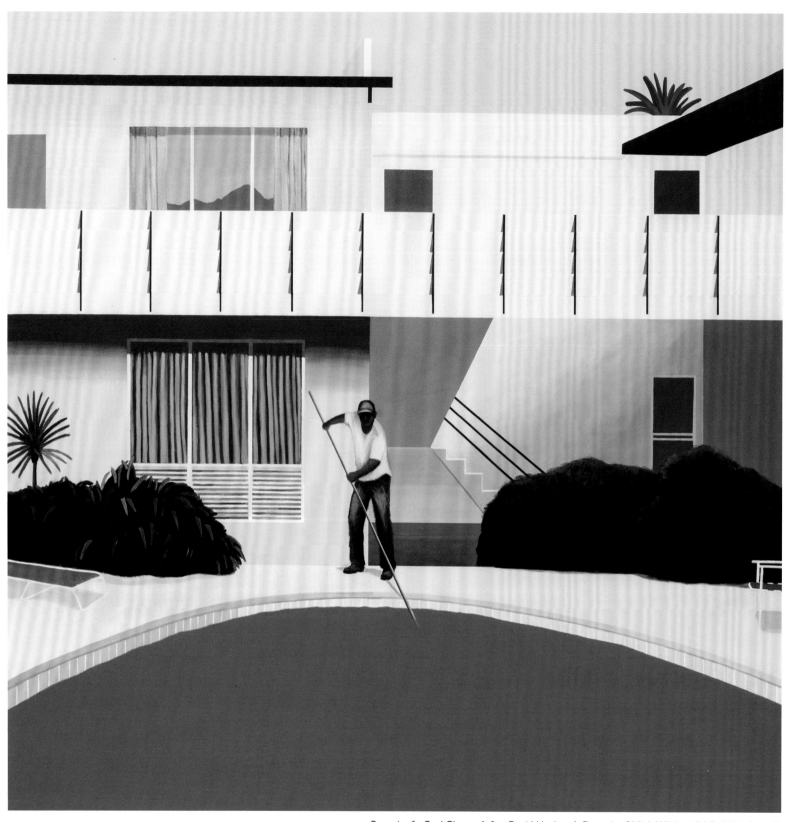

Portrait of a Pool Cleaner (after David Hockney's Portrait of Nick Wilder, 1966), 2014 (detail)

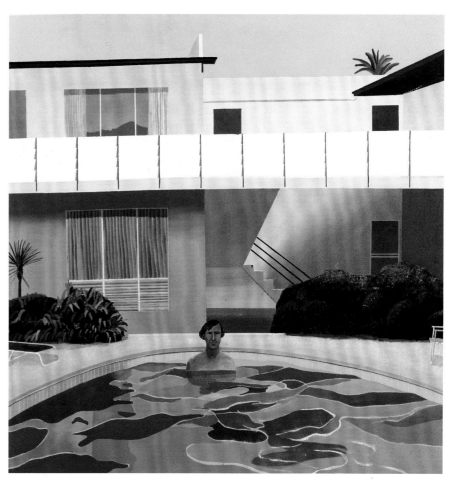

David Hockney, *Portrait of Nick Wilder*, 1966

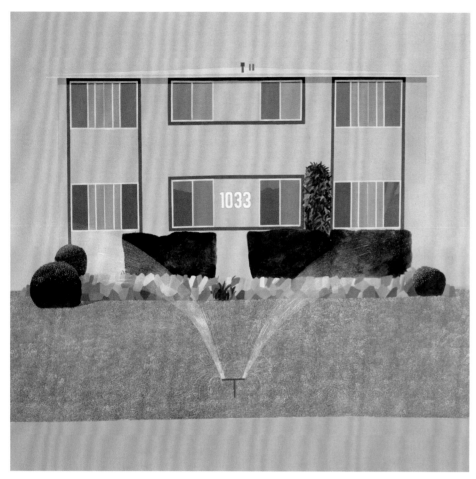

David Hockney, *A Neat Lawn*, 1966

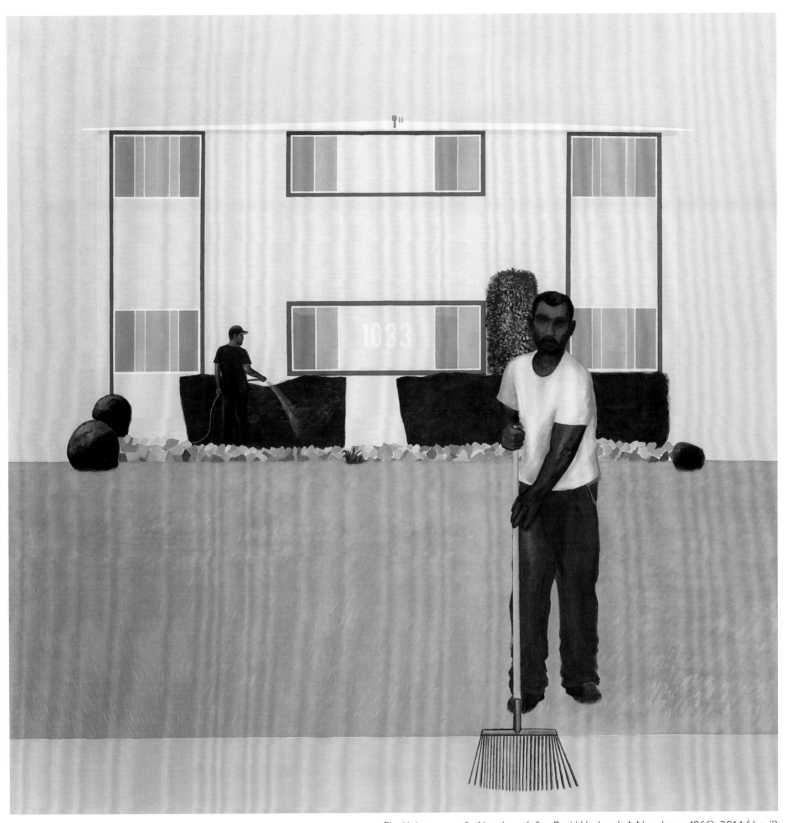

The Maintenance of a Neat Lawn (after David Hockney's A Neat Lawn, 1966), 2014 (detail)

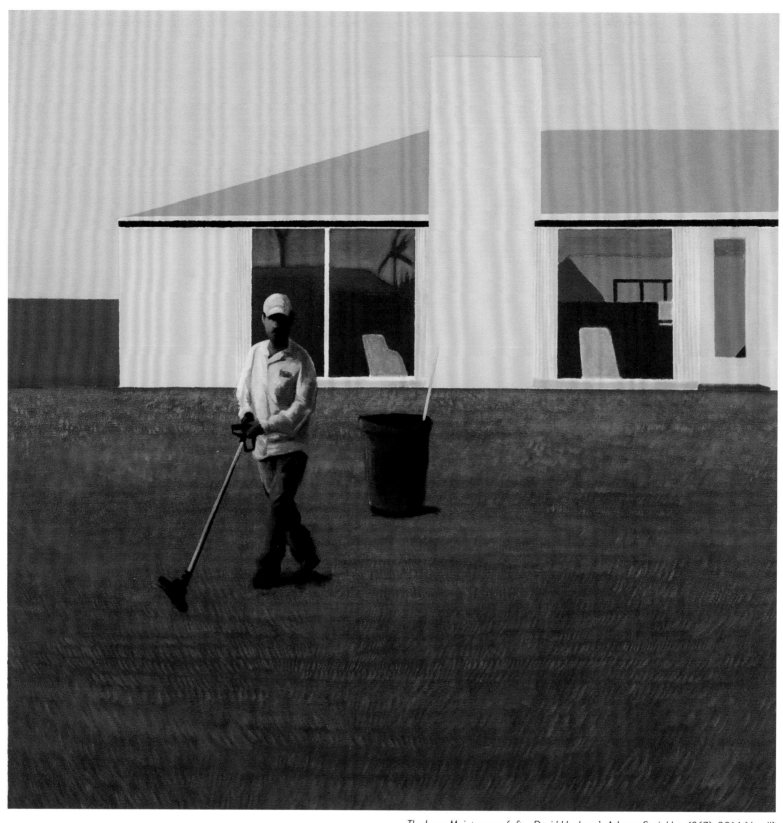

The Lawn Maintenance (after David Hockney's A Lawn Sprinkler, *1967), 2014 (detail)*

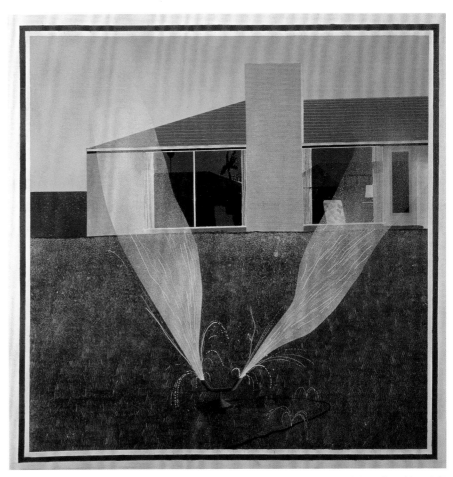

David Hockney, *A Lawn Sprinkler*, 1967

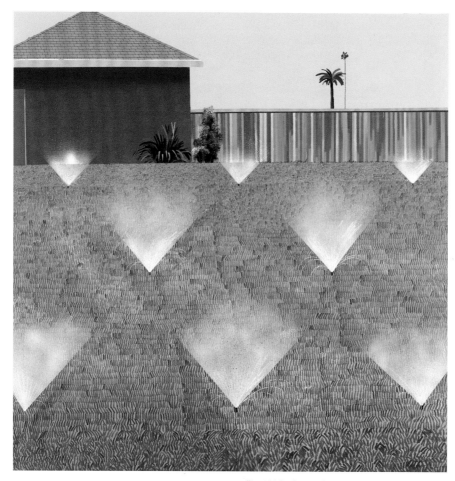

David Hockney, *A Lawn Being Sprinkled*, 1967

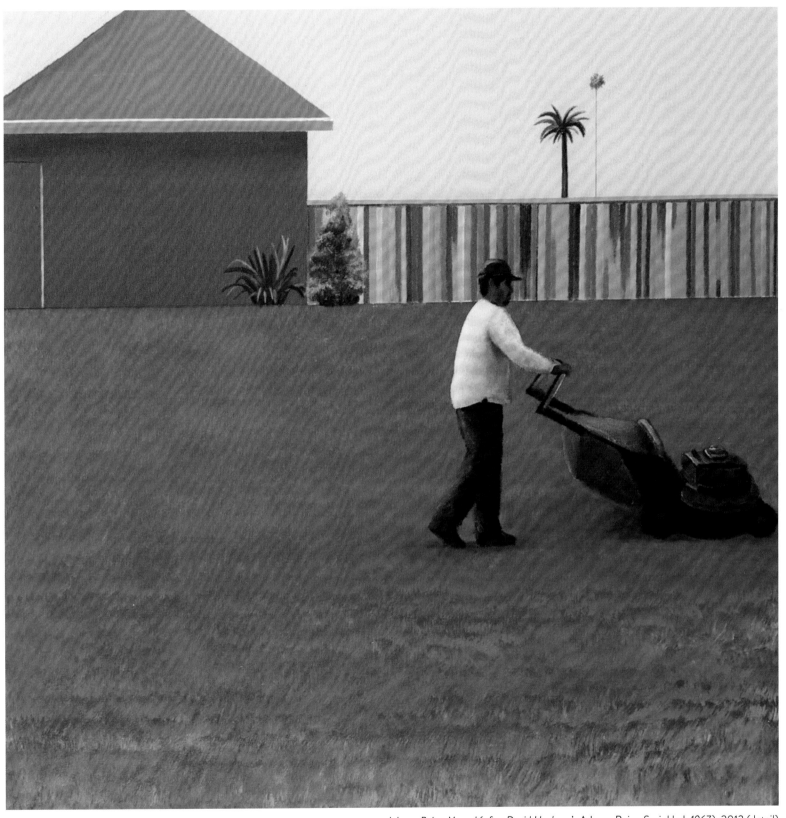

A Lawn Being Mowed (after David Hockney's A Lawn Being Sprinkled, 1967), 2013 (detail)

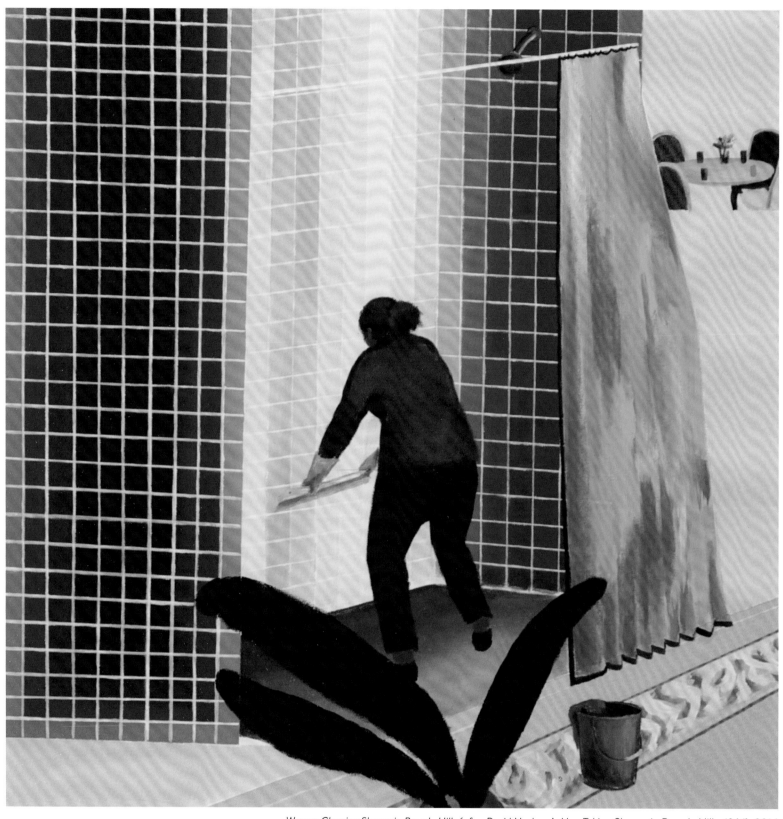

Woman Cleaning Shower in Beverly Hills (after David Hockney's Man Taking Shower in Beverly Hills, 1964), 2014

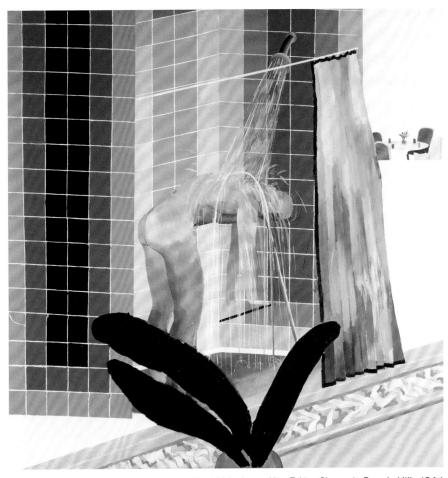

David Hockney, *Man Taking Shower in Beverly Hills*, 1964

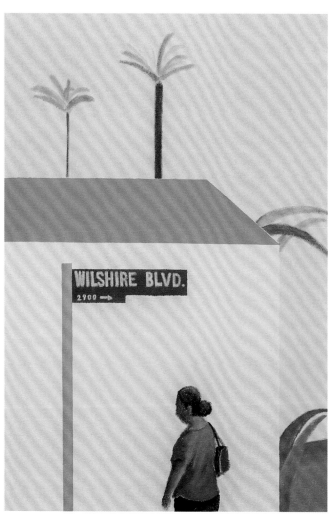

*A Woman Heading to Work, Wilshire Blvd. (after David
Hockney's Wilshire Blvd. Los Angeles, 1964), 2014*

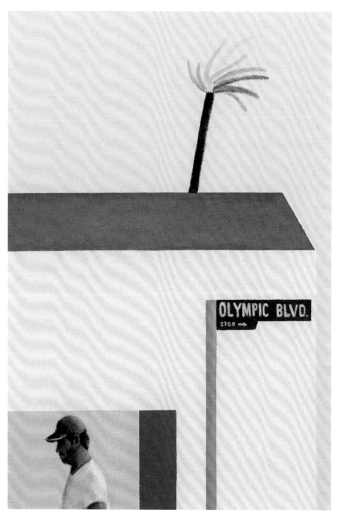

*A Man Heading to Work, Olympic Blvd. (after David
Hockney's Olympic Blvd. Los Angeles, 1964), 2014*

48

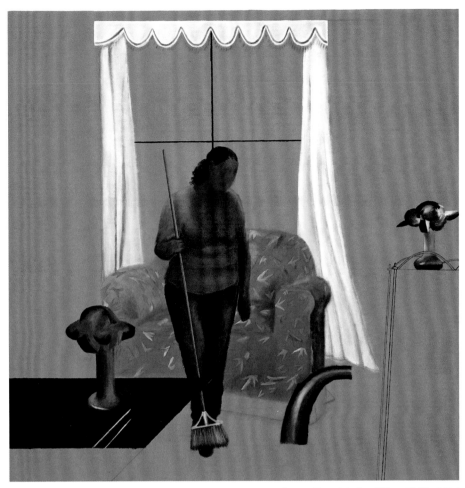

Domestic Scene, Hollywood (after David Hockney's Domestic Scene, Broadchalke, Wilts., 1963), 2014

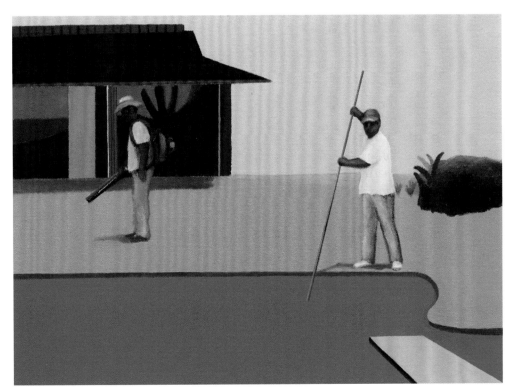

No Little Splash, 2014

MOCA, Downtown Los Angeles

West Hollywood Park

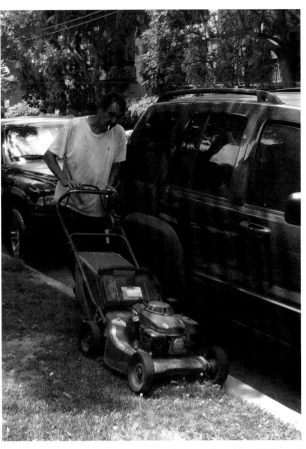

Sweetzer Ave., West Hollywood

Laurel Canyon

Kings Road Park, West Hollywood

51

Waring Ave., Los Angeles

Wynn Hotel, Las Vegas

Romaine St., West Hollywood

West Hollywood Library

Los Cuidadores (*The Caretakers*)
Mural, West Hollywood Park, 2013

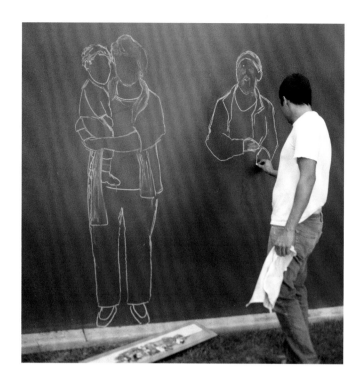

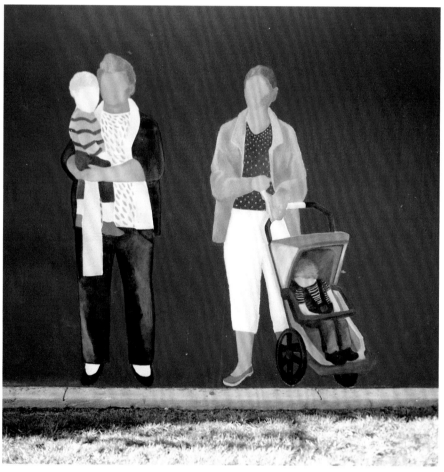

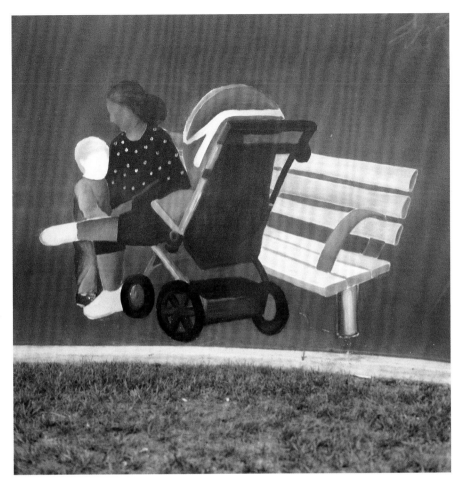

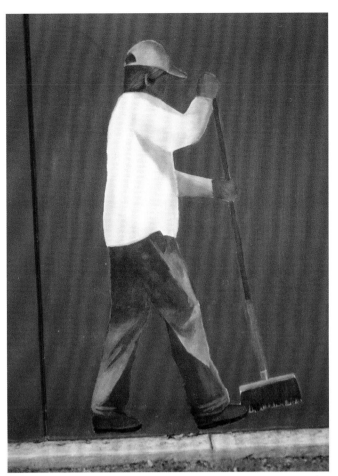

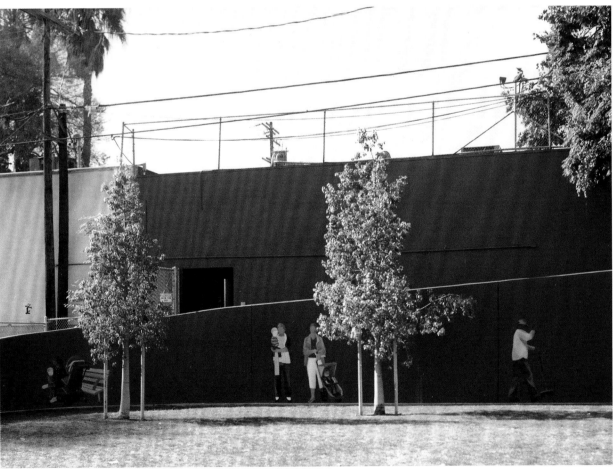

Cardboard Cut-Outs

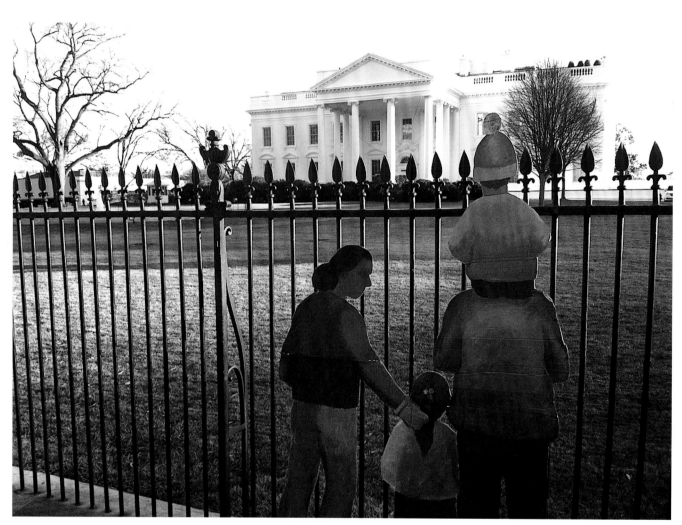

White House, Washington, DC, 2013

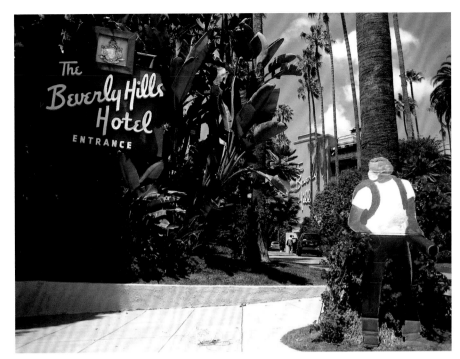

Gardener, Beverly Hills Hotel, 2012

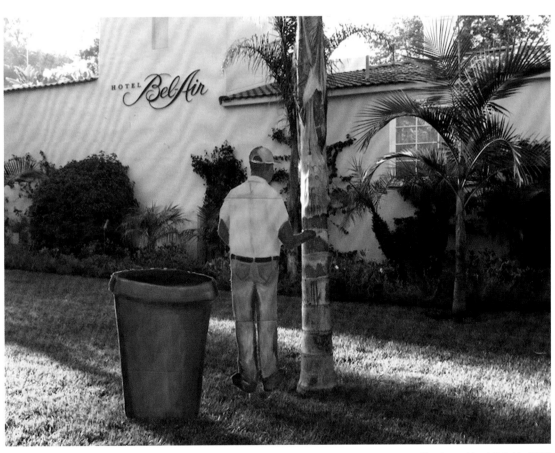

Gardener, Hotel Bel-Air, 2013

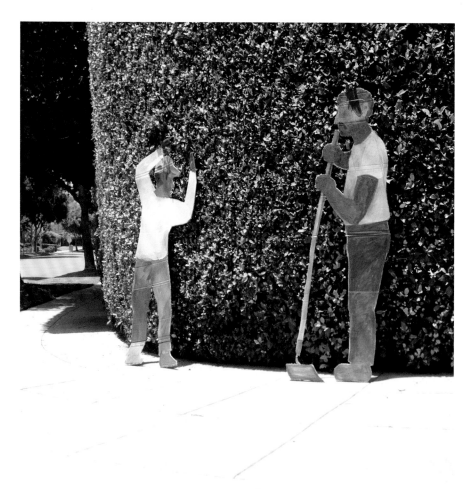

Gardeners, Doheny Dr., West Hollywood, 2012

Gardener, North Beverly Dr., Beverly Hills, 2014

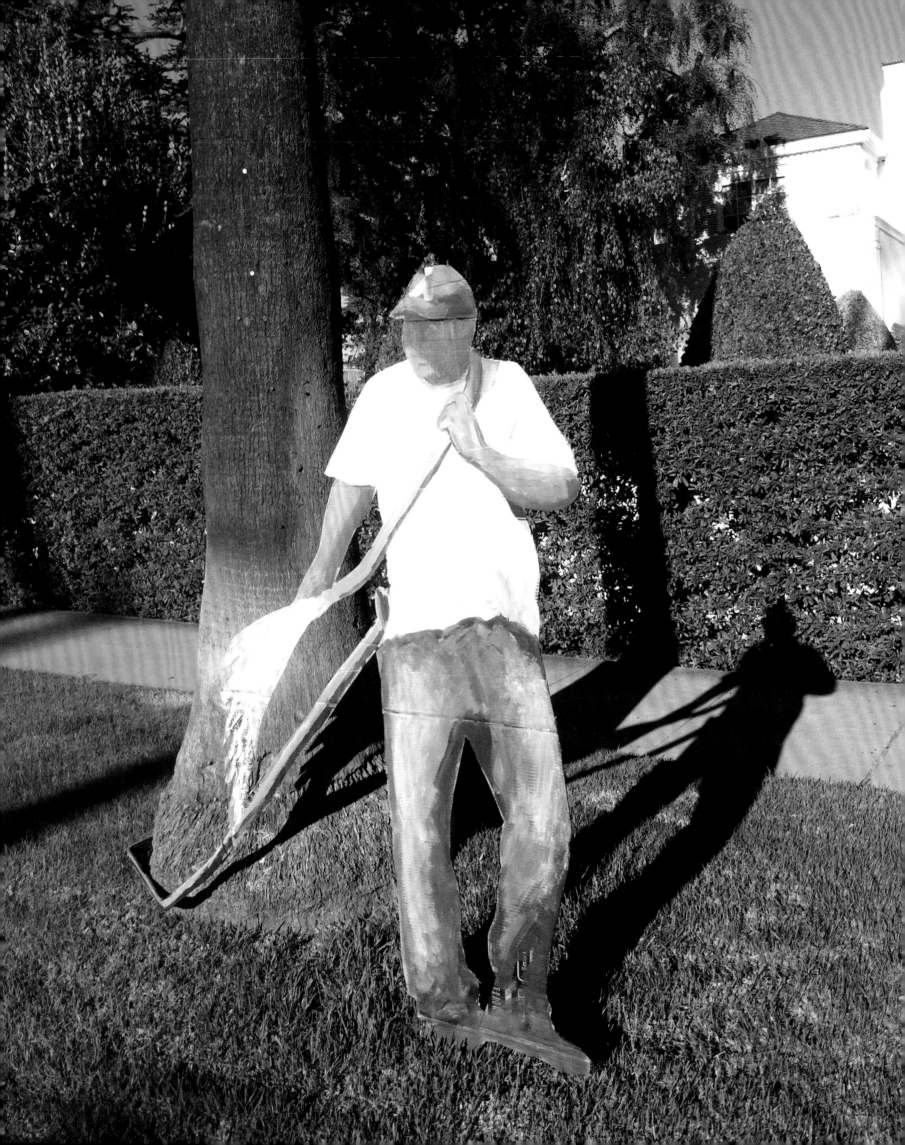

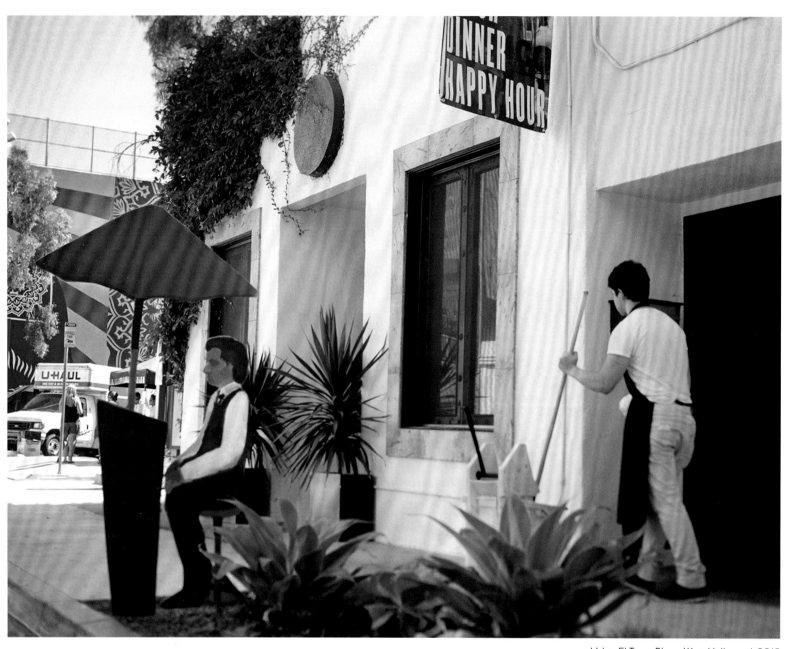

Valet, El Tovar Place, West Hollywood, 2012

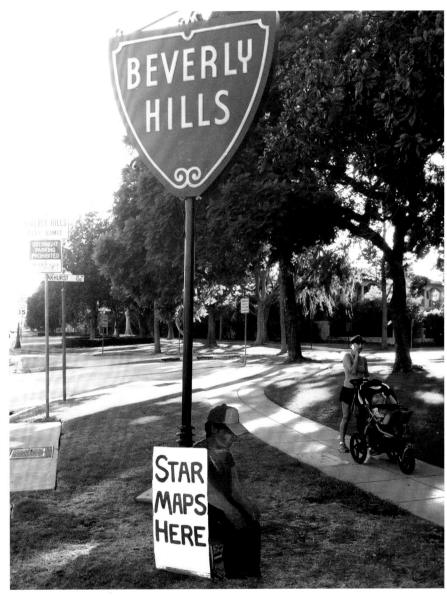

Star Maps, Doheny Dr. and Santa Monica Blvd., Beverly Hills, 2012

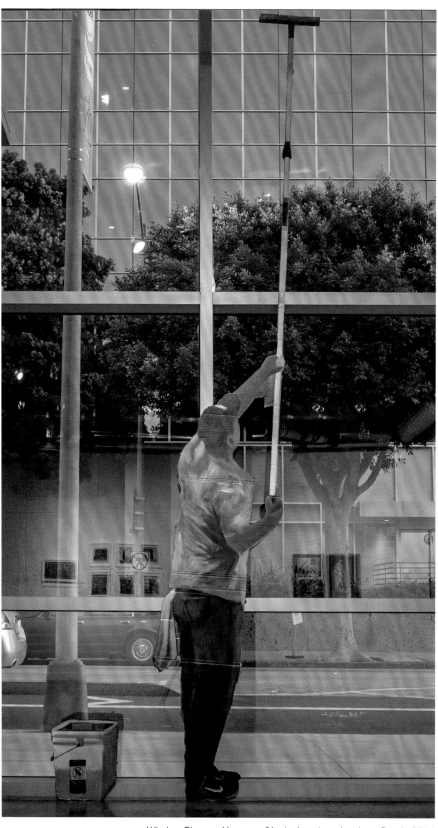

Window Cleaner, Museum of Latin American Art, Long Beach, 2014

Gardener, Mapleton Dr. and Faring Rd., Beverly Hills, 2012

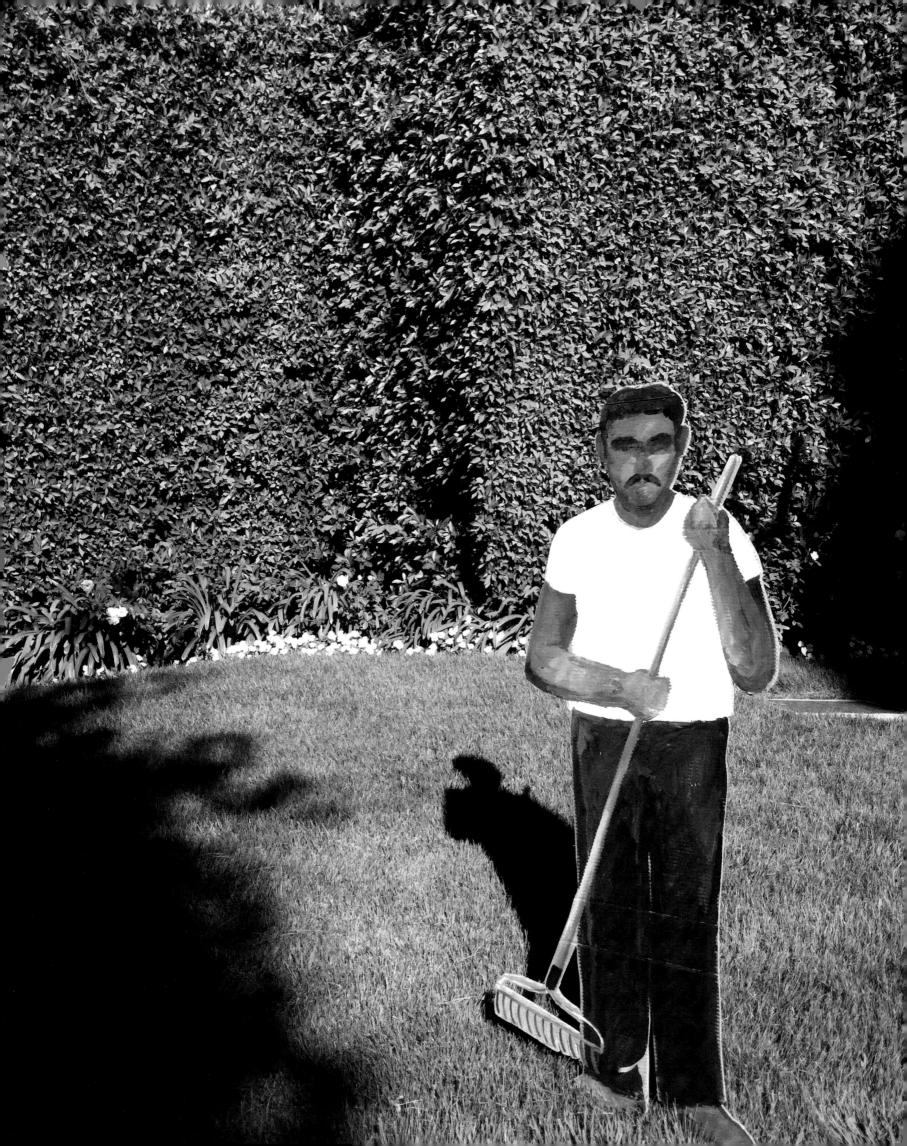

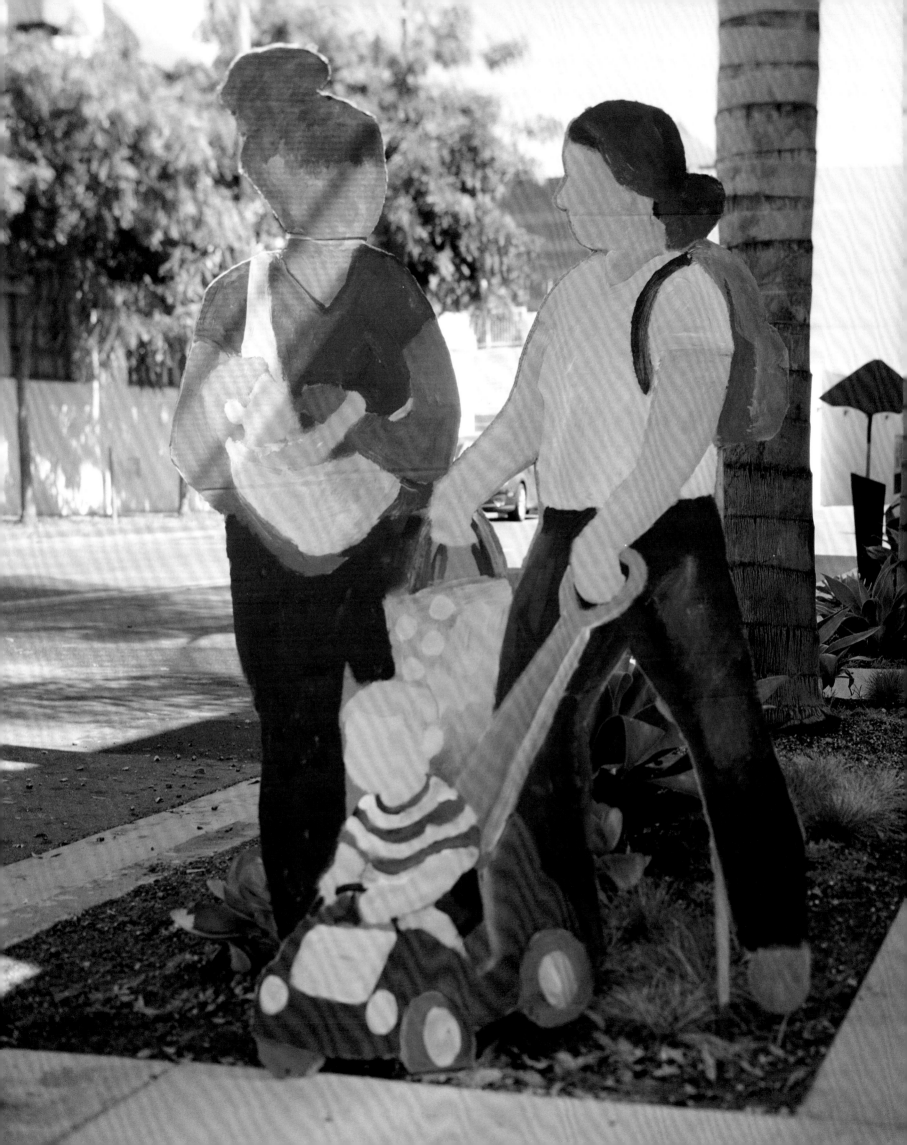

Nannies, El Tovar Place, West Hollywood, 2012

Nanny and Child, West Hollywood Park, 2013

Produce Stand 1, Grand Central Market, Los Angeles, 2014

Produce Stand 2, Grand Central Market, Los Angeles, 2014

Produce Stand 3, Grand Central Market, Los Angeles, 2014

Old Woman, Grand Central Market, Los Angeles, 2014

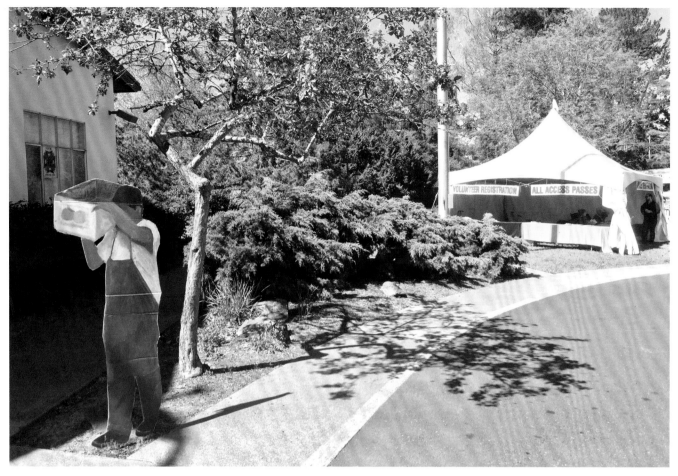

Produce Man, Sebastopol, 2015

Gardener, Tucson Museum of Art, Arizona, 2015

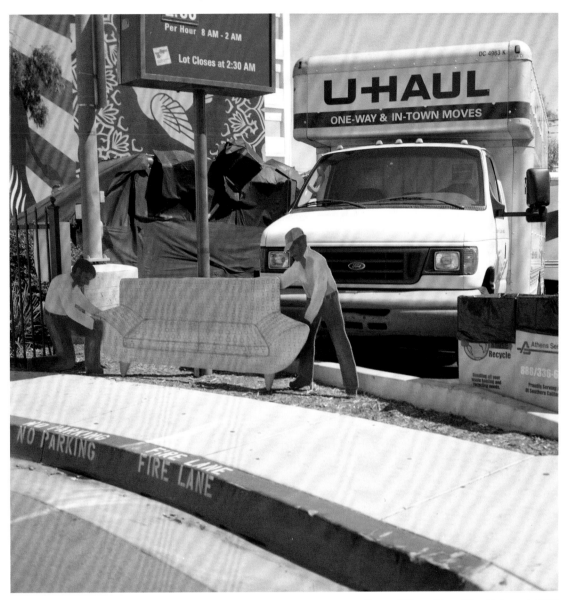

Movers, El Tovar Place, West Hollywood, 2012

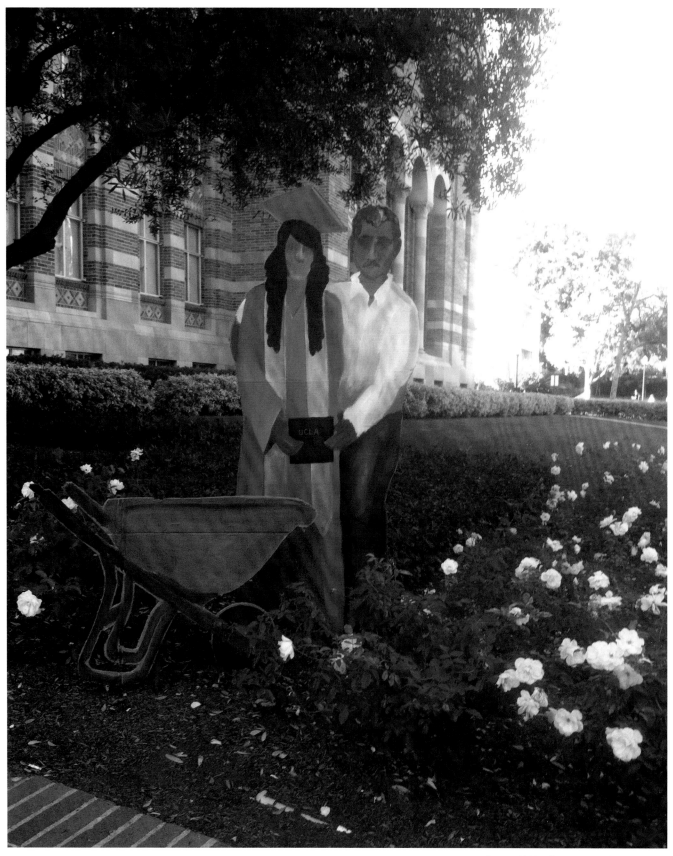

Juntos, UCLA Campus, Los Angeles, 2013

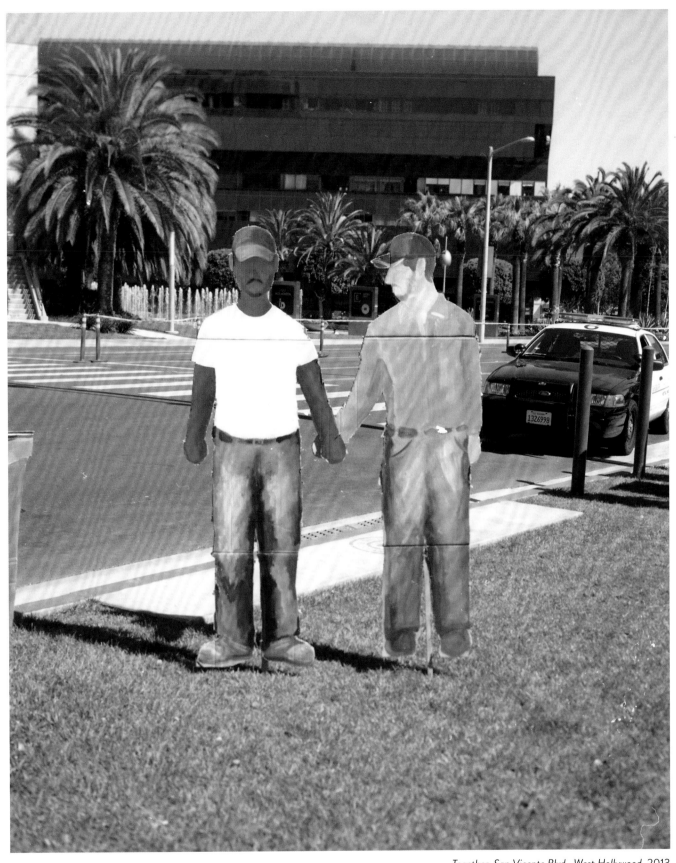

Together, San Vicente Blvd., West Hollywood, 2013

Los Olvidados (*The Forgotten*)
Saguaro National Park, Arizona, 2012

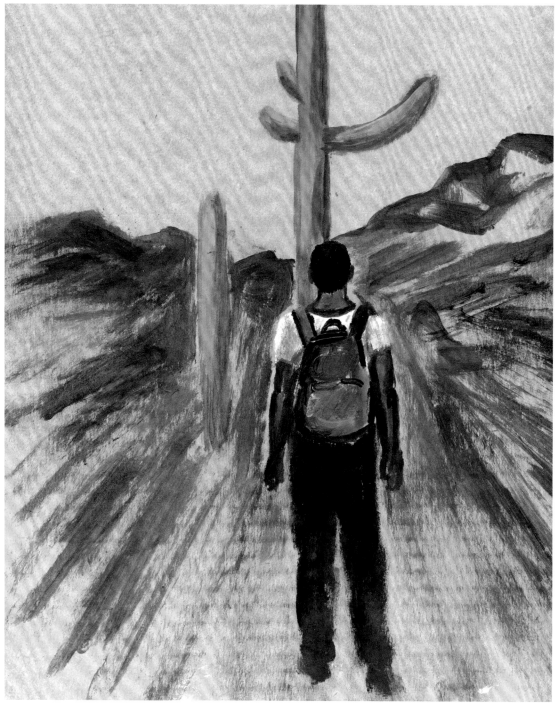

Man with Backpack, 2015

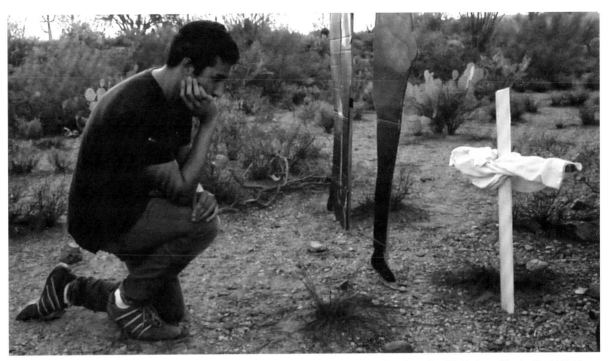

Still from *Los Olvidados*, a film by David Feldman

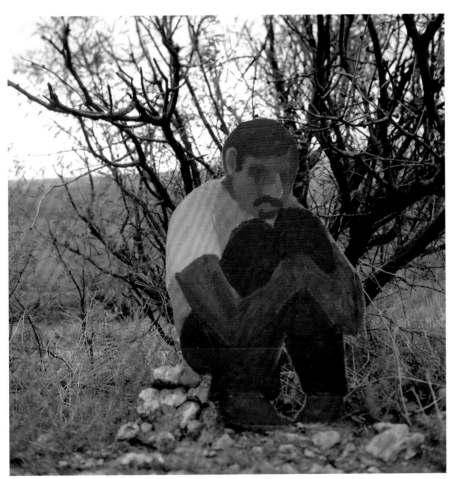

Lost Man, Rio Rico, Arizona, 2012

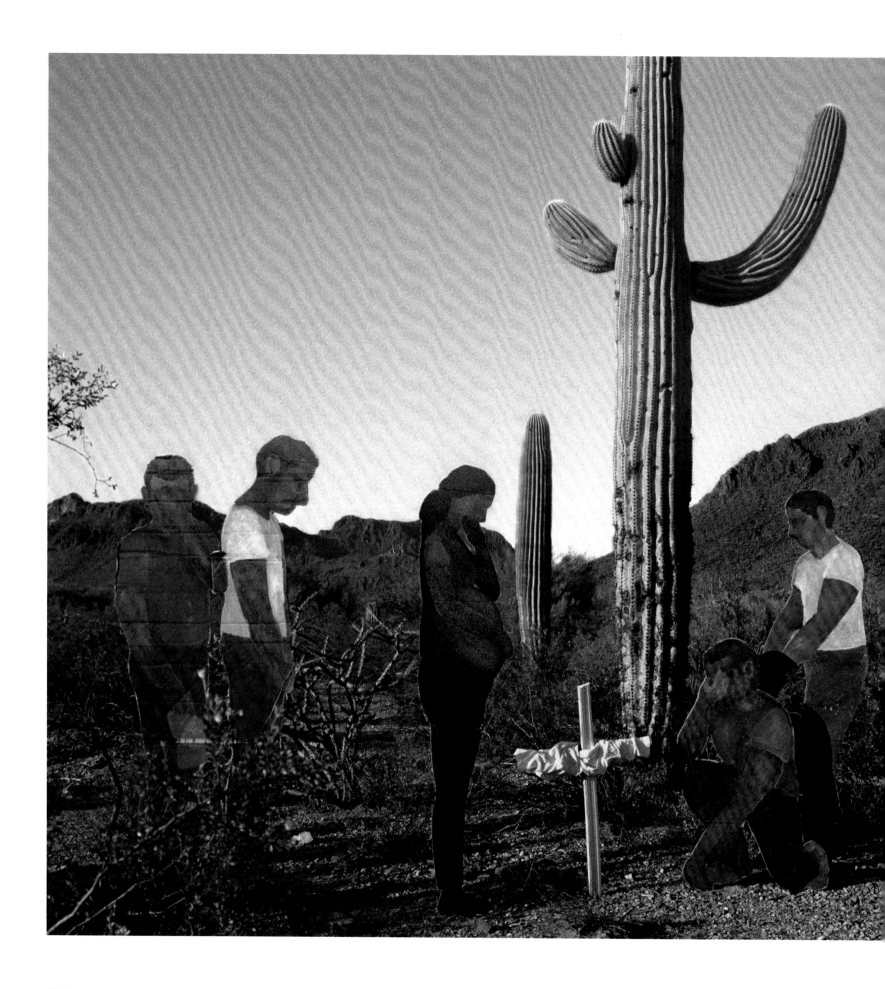

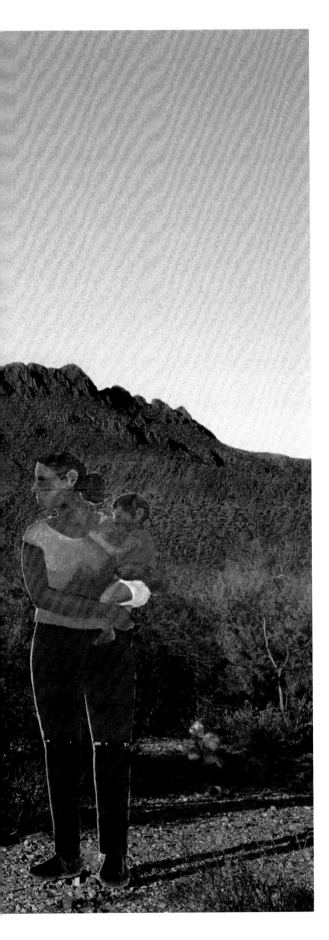

Los Olvidados (The Forgotten), 2012

Magazines

(Acrylic on magazine pages)

Self-Portrait, 2013

Estela and Dylan, 2013

OVERLEAF LEFT
Heracio, 2014

OVERLEAF RIGHT
Esperanza Making the Bed, 2014

The Homemakers

Flor in Landon's Room, 2014

Esperanza at the Changing Table, 2014

Rosalia at Naptime, 2015

Antonia Waiting for Her Check, 2013

Carmen Waiting for Her Check, 2013

Maria Waiting for Her Check, 2013

Erizalda Resting, 2014

84

American made.

Internationally admired.

LOUNGE**22**
hand crafted in los angeles

Misael Waiting for His Check, 2013

Grizelda Takes a Break, 2013

Laundry Day, 2014

Miriam's Reflection (the New Gilded Age), 2013

Abelina, 2014

Two Day Laborers Waiting to Be Paid, 2013

Nemesio Napping, 2014

89

Lupe Setting the Table, 2014

Eduardo the Day Laborer, 2013

Hilario on the Hillside, 2014

Citlali, 2014

Wilma and Landon, 2013

Hilario and Hector Waiting for Their Check, 2013

Lightness and Heaviness, 2013

The Grape Pickers, 2014

The Next Generation Escalade, 2014

OVERLEAF
DVF, 2015

Macario Disappearing, 2014

Notes and Instructions
(Trompe l'oeil acrylic on panel)

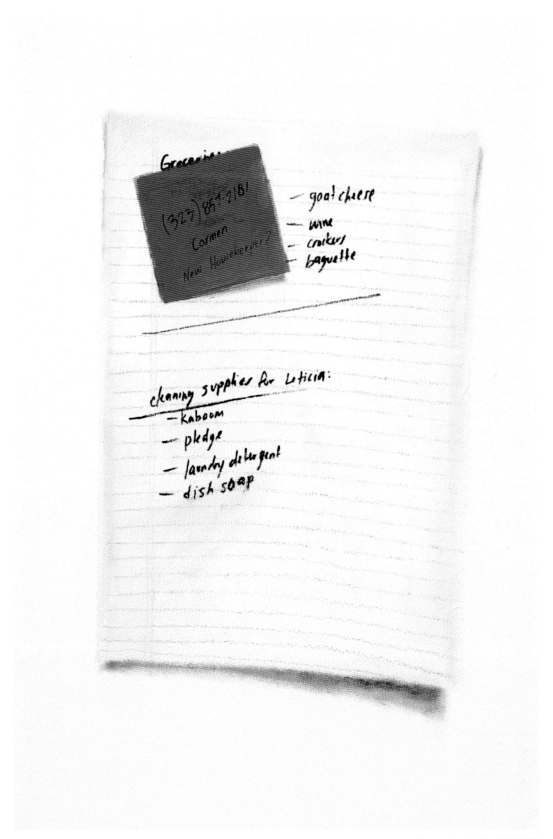

Instructions for Leticia, 2013

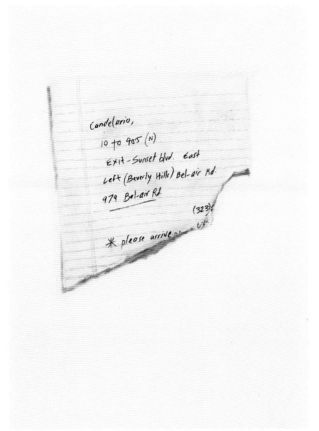

Directions for Candelario, 2013

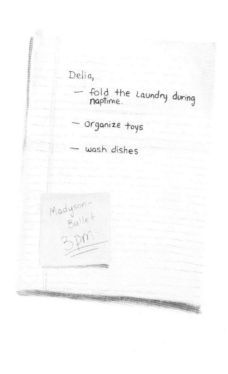

Instructions for Delia, 2013

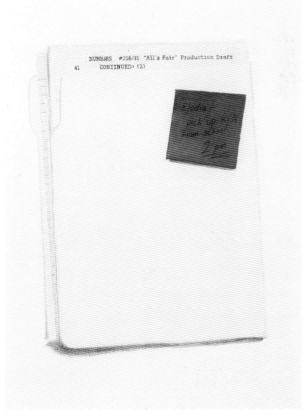

Instructions for Elodia, 2013

Large-Scale Mixed Media
(Acrylic on archival pigment print)

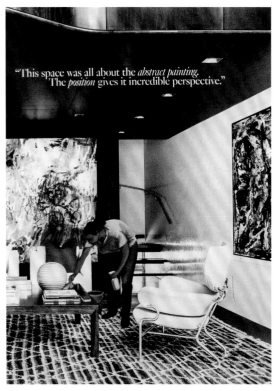

Abstract Painting, 2015

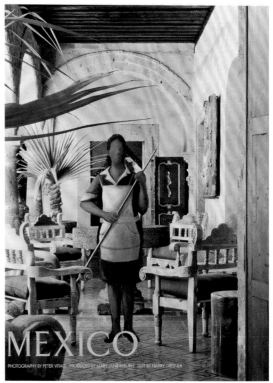

Mexico, 2014

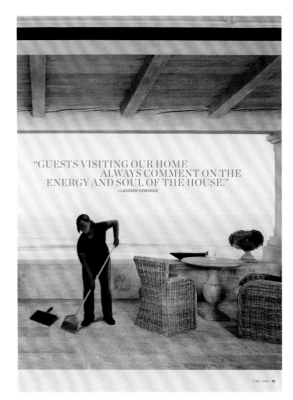

Energy and Soul, 2015

Working for the Weekend, 2014

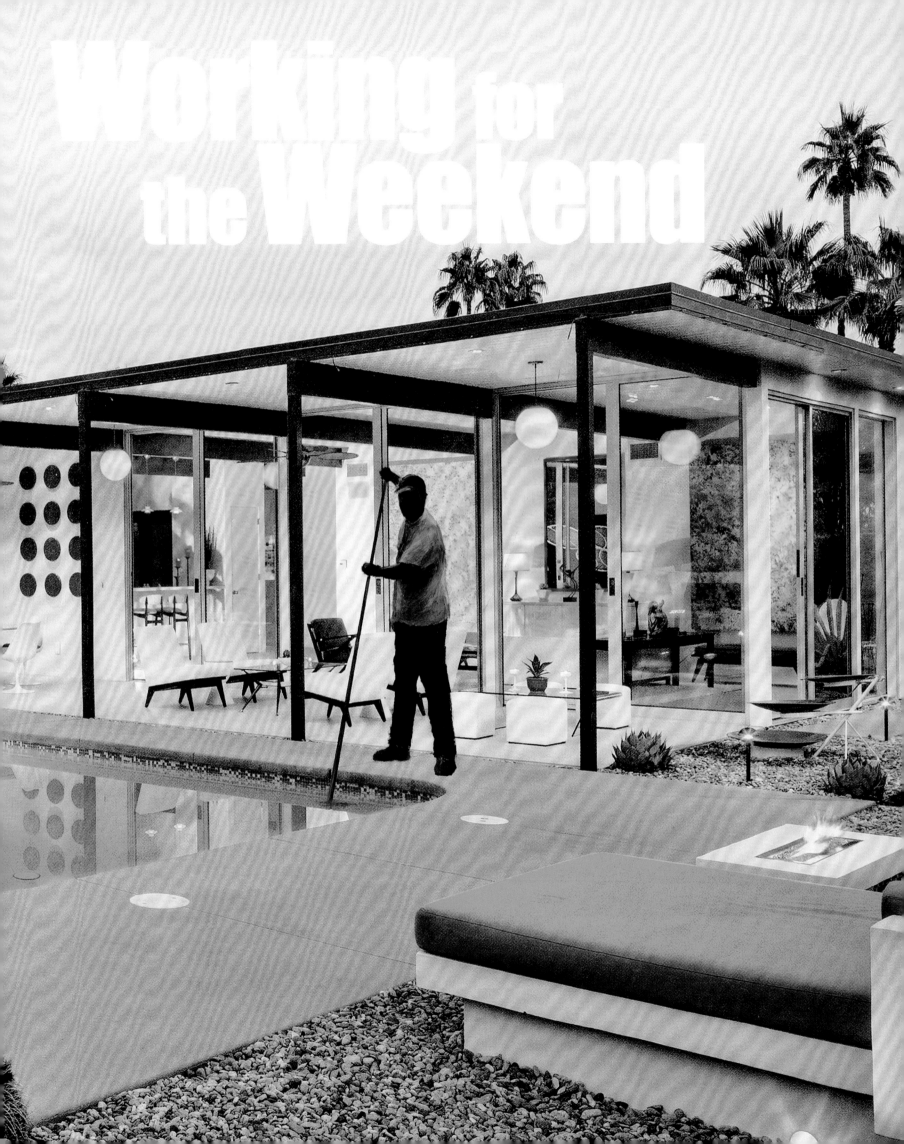

Working for the Weekend

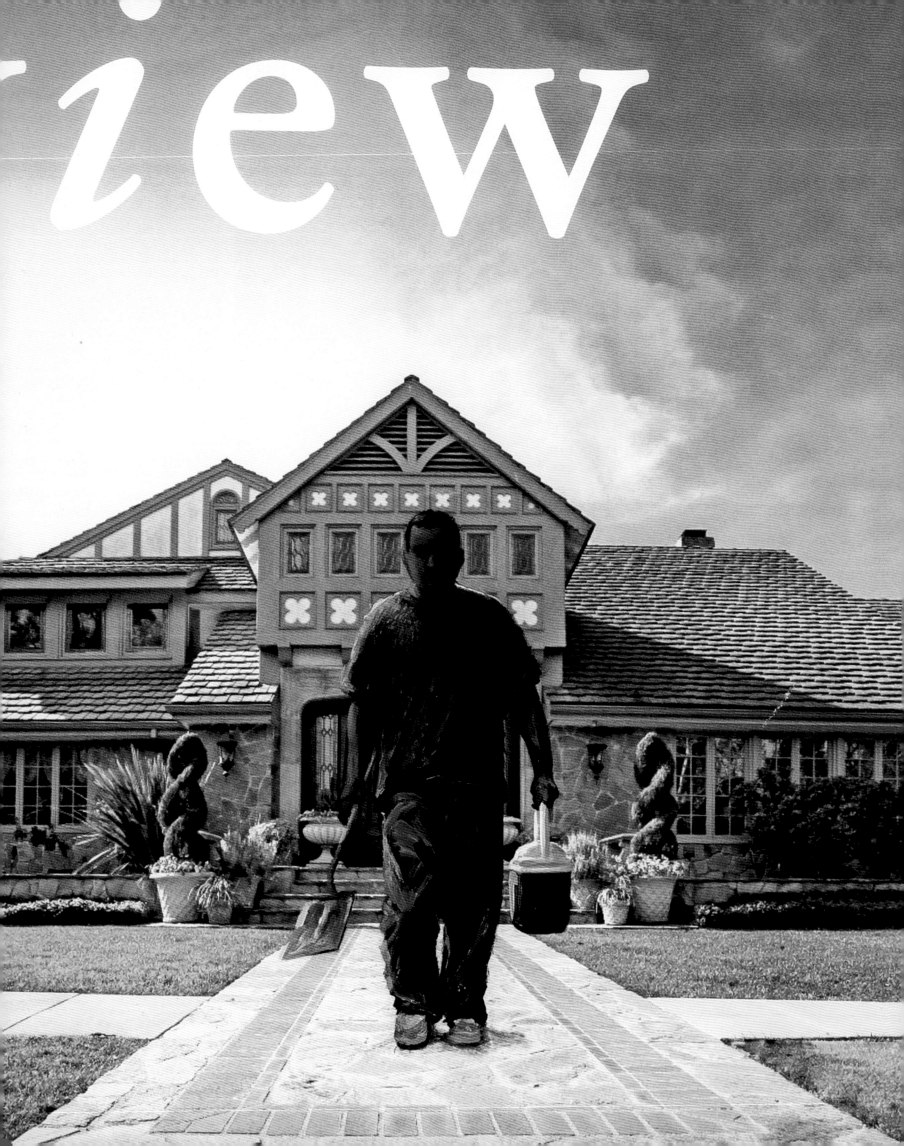

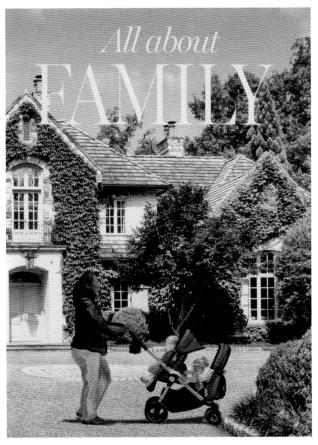

All About Family, 2014

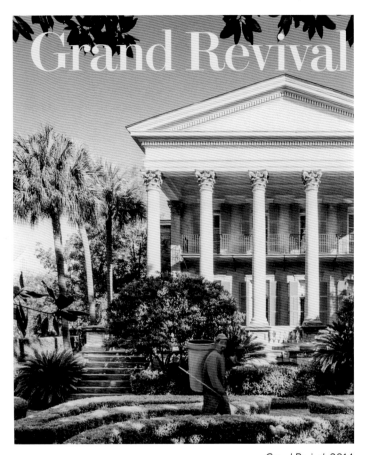

Grand Revival, 2014

View (Shovel), 2015, above; detail opposite

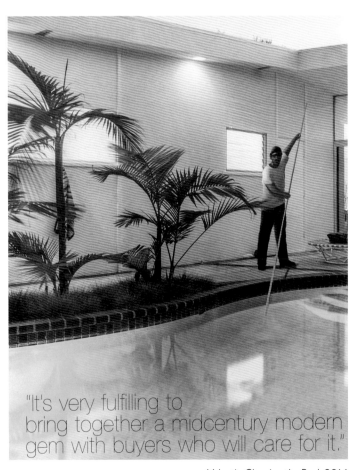

Valentin Cleaning the Pool, 2014

103

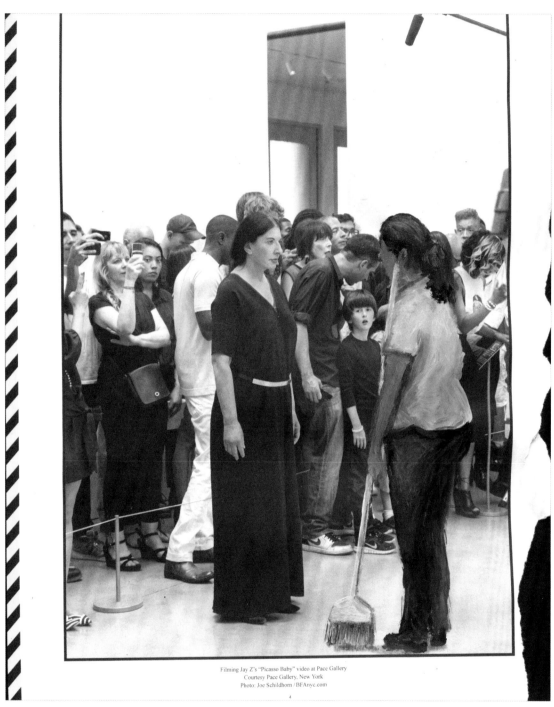

Filming Jay Z's "Picasso Baby" video at Pace Gallery
Courtesy Pace Gallery, New York
Photo: Joe Schildhorn / BFAnyc.com

The Custodian Is Present, 2014

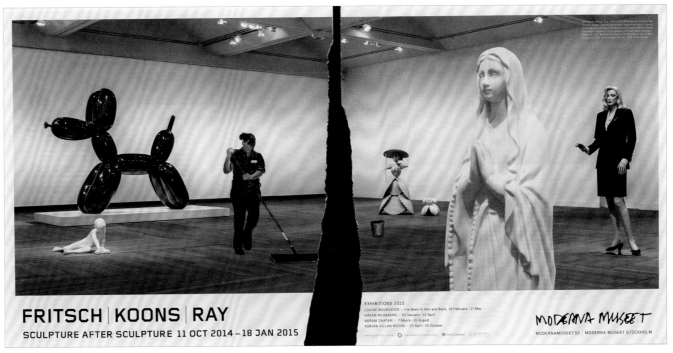

Fritsch Koons Ray, 2015

Carmen and Her Husband, Teofilo, with Hudson, 2014

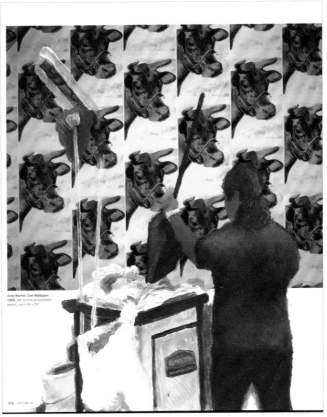

Claudia Cleaning, 2014

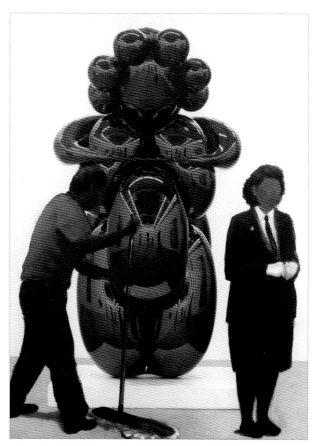

Benjamin and Adela in the Jeff Koons Exhibition, 2014

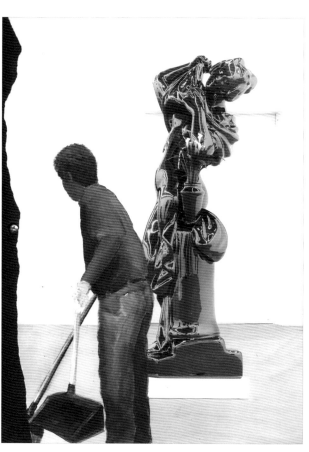

Mario Sweeping in the Jeff Koons Exhibition, 2014

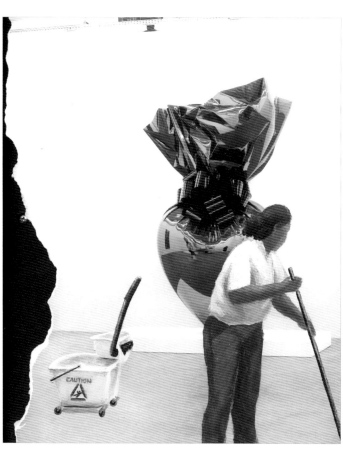

Carmelina Cleaning in the Jeff Koons Exhibition, 2014

La Limpieza, 2014

Heriberto Cleaning, 2014

Martin Sweeping, 2014

108

Juan, 2014

Yadira and Greyson in the Art Gallery, 2014

ELLSWORTH KELLY

16 MAY – 13 JULY 2012

GALERIE MARIAN GOODMAN

DU TEMPL PARI -1-48-04-7052 WWW.MARIANGOODMAN.COM

RICHARD SERRA AT GEMINI

NEW LARGE SCALE ETCHINGS

Genaro and Jacinto, 2014

Refugio, 2014

Soledad, 2014

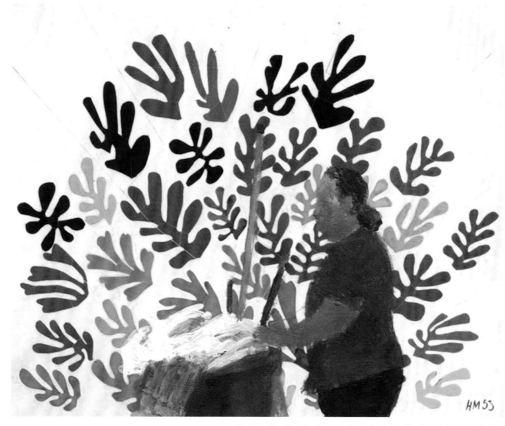

Janitor Walking in Front of Matisse's La Gerbe, LACMA, 2014

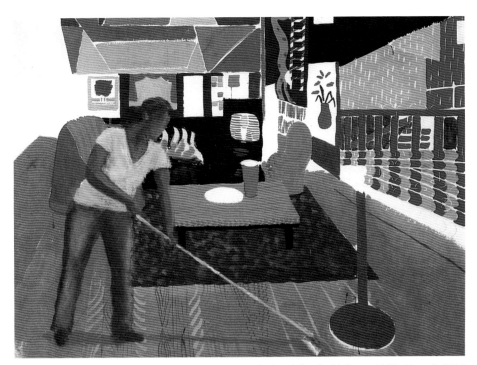

Woman Cleaning (after David Hockney's Studio Hollywood Hills House), 2014

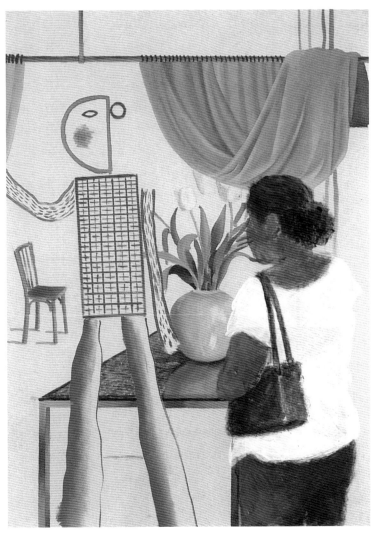

Woman Waiting (after David Hockney's Invented Man Revealing Still Life), 2014

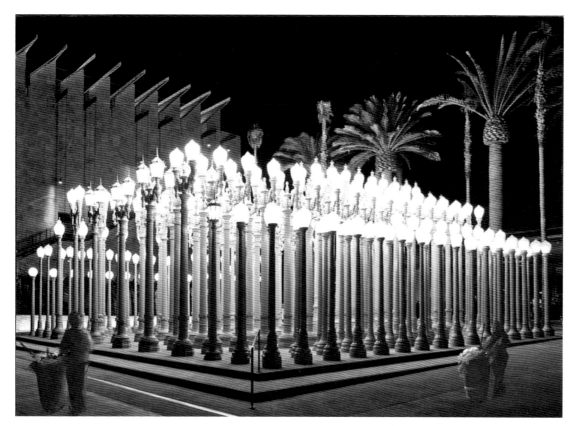

Custodians near Urban Light, 2014

Custodians, LACMA, 2014

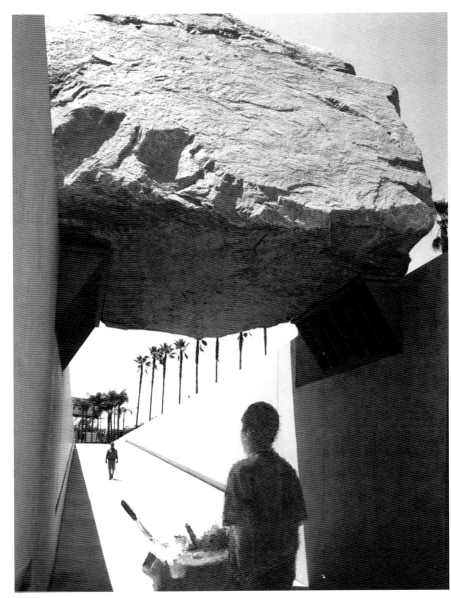

Janitor Under Levitated Mass, 2014

Michigan *Cut-Outs*
University of Michigan Institute for the Humanities, 2015

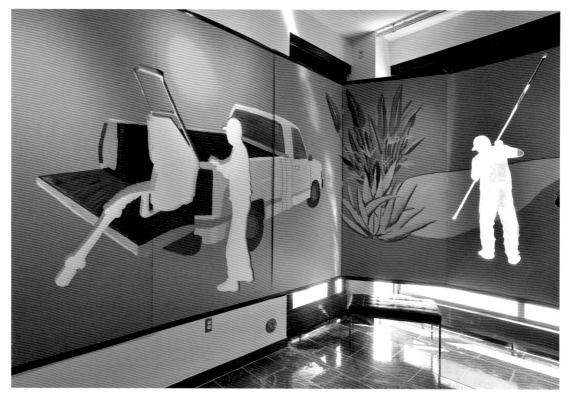

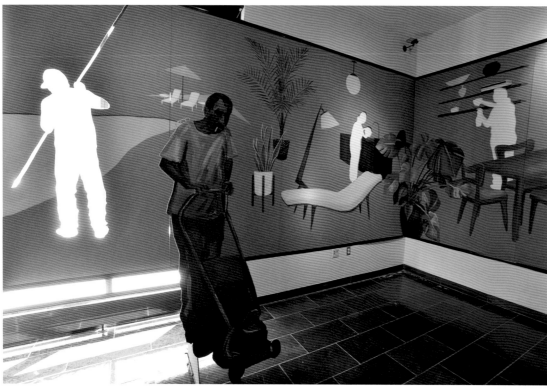

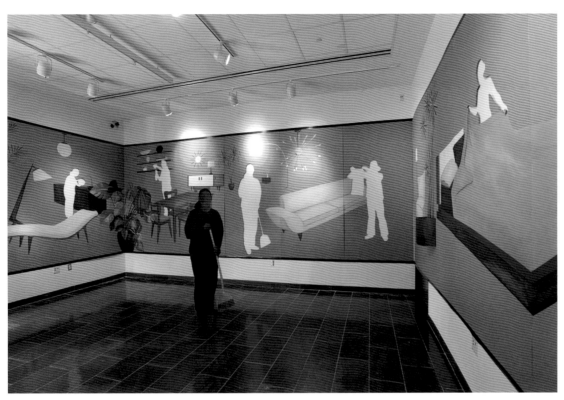

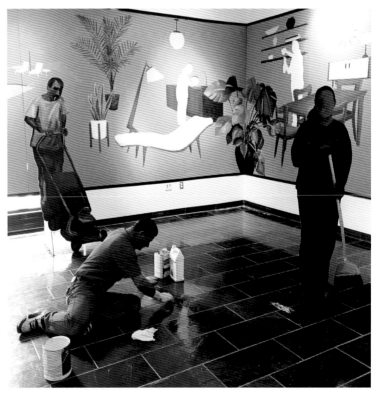

Digital Drawings and Lightboxes

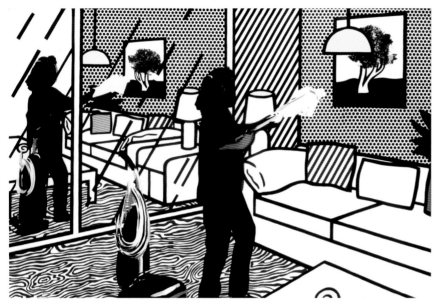

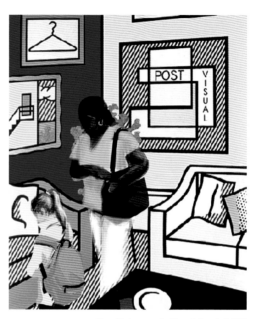

Noella Cleaning (after Roy Lichtenstein, Wallpaper with Blue Floor Interior), 2015

Roy Lichtenstein Post Visual, 2015

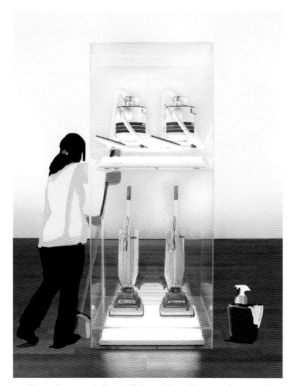

Clara Cleaning (after Jeff Koons New Hoover Convertibles, New Shelton Wet/Drys 5-Gallon Double Decker), 2015

Jardín
(Oil stick and acrylic on panel)

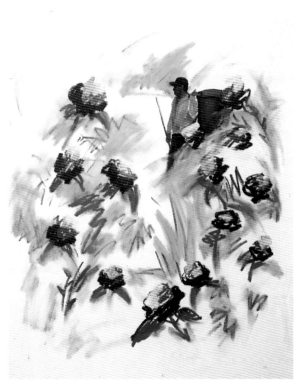

Jardín no. 3, 2015

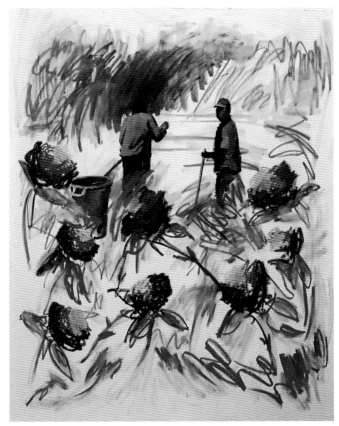

Jardín no. 1, 2015

Jardín no. 2, 2015

*Antes de ser hispano o latino,
el vuelo de la imaginación
es sencillamente humano . . .*

Before being Hispanic or Latino,
imagination's flight is simply human . . .

—Felipe Ehrenberg[1]

FOR AN ARTIST OF MEXICAN DESCENT living in the United States, sharing his or her culture represents a challenging act of bravery. From Diego Rivera's notoriously ill-fated commission at Rockefeller Center in 1933 to Sandra de la Loza's actions and interventions through the Pocho Research Society of Erased and Invisible History around downtown Los Angeles in 2002, Mexican[2], Mexican American[3], and Chicano artists[4] have used their identities to give a voice to their people and raise awareness surrounding issues unique to the immigrant experience—an action perceived by many as a rebellious act. One such artist, Ramiro Gomez, depicts childcare workers as a painted trompe l'oeil on the otherwise bare green walls of West Hollywood Park in his art installation *Los Cuidadores* (*The Caretakers*) (2013) (p. 56). This illusion poignantly makes visible the invisible: a community to which Gomez belonged while working as a nanny to support himself early in his career—an experience that continues to inform and humanize his visual narratives.

Gomez was born to undocumented immigrant parents in San Bernardino, outside of L.A. in the Inland Empire, in 1986—the same year that the Immigration Reform and Control Act (IRCA) was

Ramiro Gomez, *Azul Limpiado (after Matisse)*, 2015

signed into law by President Reagan. Nearly three decades later, his work goes beyond the Latino immigrant experience by breaking with the art-world power structures that often present works by Latinos as outsider art or ethnic art not deemed appropriate for the white cube. Versed in art history, Gomez intervenes[5] and appropriates the works of modern and contemporary artists such as Henri Matisse, David Hockney, and Jeff Koons, as well as Old Masters such as Diego Velázquez, shedding light on the work of gardeners, housekeepers,

caregivers, night-shift cleaning crews, and other immigrant workers who support the lifestyles of those who consume the very art he's appropriated.

In his first body of work, titled Cardboard Cut-Outs, Gomez inserts life-size, faceless, brown-skinned figures—representing the many immigrant laborers with whom Gomez is well familiar, but who remain anonymous to most—in the landscape. Centering on affluent L.A. neighborhoods like West Hollywood and Beverly Hills, the work extends as far afield as Washington, DC. In *White House* (2013) (p. 58), Gomez uses cardboard and acrylic paint to depict a young immigrant family leaning against the black metal fence of the president's residence. A mother in profile caresses the head of her daughter, a girl of approximately eight who stands next to her father, who carries the youngest member of the family on his shoulders. With its subjects all dressed modestly in blue and gray garments, unprotected from the cold East Coast winter weather and stuck outside the gates, this work reframes the typical scene at this iconic national landmark. In the ubiquitous photographs from proudly posing tourists and professional photographers highlighting its pristine facade and immaculate lawn, the White House is traditionally portrayed as a symbol of stability and protection, a place, like the country itself, where everyone is welcome. Gomez challenges and complicates those ideals with his cutouts, a trompe l'oeil work that deceives passersby and public-service agents alike, transforming them into audience members who must now consider the existence of families like the one depicted concurrent with the immigration debate of late 2012.

In addition to *White House*, the Cardboard Cut-Outs series includes a number of strong works. *Distant Parallels* (2014) (p. 64), an intervention presented at the Museum of Latin American Art's

Luis Jiménez, *Border Crossing/Cruzando El Rio Bravo*, 1989

satellite space in downtown Long Beach, California, introduced a window cleaner working on the museum building, and an installation at Grand Central Market in downtown Los Angeles for the *LA Weekly*'s May 2014 Artopia event depicted the Latino fishmongers and produce merchants who work there (pp. 68-69). These interventions are poignantly related to the work of many Chicano artists of the 1970s and 1980s, including Luis Jiménez's *Border Crossing/Cruzando El Rio Bravo* (1989, above) and David Botello and Wayne Alaniz Healy's installation *La Familia* from the L.A. mural *Chicano Time Trip* (1977), which portrays the struggles facing immigrant families arriving in the United States. Additionally, Gomez seamlessly incorporates a visual sensibility evocative of graphic artists like Rupert García in *¡Cesen*

Ester Hernández, *Sun Mad II*, 1981

deportación! (Cease Deportation!) (1973), and Ester Hernández in *Sun Mad II* (1981, above), who call for an end to the exploitative treatment of migrant workers who are allowed to cross the border only to be deported at the whim of US economic and political interests. Gomez distinguishes himself as a politically mindful artist who places differences of race and socioeconomic status at the core of his discourse. His cutouts emerge with an abstracted and powerful graphic presence, articulating the artist's greater national consciousness while still representing a community tied closely to his personal identity as a child of immigrants.

Inspired by his personal experience working as a nanny, Gomez also transfers the characters depicted in his Cardboard Cut-Outs series onto the pages of luxury home and garden magazines. In doing so, he asserts himself as a non-white artist who faces similar challenges to the Mexican and Mexican American laborers working in these lush settings. In *Self-Portrait* (2013) (p. 78), a faceless Gomez stands in front of a

Versailles-like garden holding two children, the older at the hip and the younger in a baby carrier. Contending with the paradox of the art world, in which the artist is at once the creator and the subject, Gomez calls attention to those who, like him, maintain and support the lavishness presented in the magazines read by his employers. Gomez's Magazine series is also reminiscent of Adrian Piper's Vanilla Nightmares series (1986), where Piper intervened in *New York Times* articles and in luxury advertisements, creating charcoal drawings of black people overpowering the white individuals shown in the ads. In these works, Piper exposed issues of race and politics that were often diluted by the media of the 1980s, challenging and exposing presumptions that make it difficult for some people to see those with a different skin color in a fully human manner. As with Piper, whose conceptual practice includes both her personal subjectivity and the audience's participation, Gomez draws attention to the larger socioeconomic construct as one that includes him, and thus confronts viewers with that which they choose not to see.

Gomez extends his Magazine series to the canvas and beyond, inconspicuously inserting images of day laborers, cleaning ladies, and other janitorial workers into museum-bought postcards of well-known masterworks. This series gives way to a new—and freer—body of work, where Gomez uses his images to protest issues that affect him directly, such as the white male–dominated art world, in which the Latin American artist is segregated from the mainstream art market and rendered as invisible as the individuals depicted in so many of Gomez's works. Using strategies similar to those used by artists such as Jeff Koons (who is known for appropriating mass consumption products such as vacuum cleaners and inflatables), Gomez continues to explore the relationship between the art world and those employed to ensure that its galleries, art fairs, and museums

continue to look presentable for the audiences they serve. Fascinated by David Hockney's work, Gomez created a series of works that appropriate the artist's Splash series, but change key elements and titles to show the concealed immigrant worker. In *No Splash* (*after David Hockney's* A Bigger Splash, *1967*) (2013) (p. 35), a nod to David Hockney's iconic painting, Gomez replicates the painting's scale and basic structure, but replaces the splash with a pool cleaner and a housekeeper who subtly interrupt this classical 1960s Southern California scene. By erasing the splash, Gomez not only makes us aware of the people who maintain these luxurious poolside settings, but he also makes clear the distant realities between the subjects in each representation: Work displaces recreation and desire.

In April 2015, Gomez merged all of his processes for *Cut-Outs* (p. 117), an installation at the University of Michigan Institute for the Humanities. Gomez constructed a cardboard wall to cover the gallery walls, including its floor-to-ceiling windows. The gallery was transformed into the interior of a midcentury-modern house in which pool cleaners and housekeepers appear as cutout silhouettes. As the sunlight streams unfiltered through the gallery, Gomez's work becomes a quasi-cinematic environment where the figures in the space materialize as members of the cleaning crew. In a mind-bending act that liberates these immigrant workers from their domestic existence, they become their own advocates, and in turn, liberate Gomez from his activist role.

In an era where appropriation[6] has exploded, Gomez also distinguishes himself through digital drawings using his iPhone Sketches app to create new works inspired by Henri Matisse's cutouts (p. 120). His work humanizes the immigrant experience and transcends nationality and race to affirm Gomez as a post-Chicano artist[7] who belongs in the mainstream globalized contemporary art world.

NOTES

1 Sylvia M. Gorodezky, *Arte Chicano como cultura de protesta* (México: Centro de Investigaciones sobre Estados Unidos de América, Universidad Nacional Autónoma de México [UNAM], 1993).

2 Those who were born in Mexico and who incorporate a nationalistic aesthetic and revolutionary iconography that are closely linked to muralists Diego Rivera, José Clemente Orozco, and David Alfaro Siqueiros. Today, the term includes artists who work in diverse mediums and with broad concepts.

3 A generation of post-WWII artists who contributed to the nascent California iconography and its connections to the national imagery, whether as part of the American West, Spanish California, or Hollywood.

4 Artists who are rejected by both the mainstream American and Mexican cultures who create pluralistic and heterogeneous art that blends the culture of "el barrio" with religious icons and pre-Columbian motifs, giving a visual identity to the labor movement lead by Cesar Chavez and Dolores Huerta.

5 In the context of art, the term *intervention* was first used in the 1990s to describe artists who trespassed everyday activities or venues to critique, lampoon, or subtly co-opt a space outside the gallery or museum setting with strong political motivation.

6 Appropriation is the borrowing of a preexisting image from art history or mass media to create a new work. From Manet's appropriation of Raimondi and Raphael's *The Judgment of Paris* to Picasso's paraphrasing of Manet's work, and later Koons's *Antiquity (Manet)*, artists have used other artists' works inspirationally, referentially, and critically to continue to expand the art discourse.

7 As described by Max Benavidez in his essay titled "The Post-Chicano Aesthetic: Making Sense of the Art World" in *Post-Chicano Generation in Art: Breaking Boundaries* (Phoenix: MARS Artspace, 1990). The term *post-Chicano* is used to describe art that veered away from a collective sociopolitical agenda and that is closely related to postmodernism preference for ambiguity, nonlinearity, and spontaneity, among other things.

Credits

All works by Ramiro Gomez unless otherwise noted

Page 4. David Hockney. *American Collectors (Fred and Marcia Weisman)*. 1968. Acrylic on canvas, 84 × 120". Collection Art Institute of Chicago. © David Hockney

Page 5. *American Gardeners (after David Hockney's* American Collectors (Fred and Marcia Weisman), *1968)*. 2014. Acrylic on canvas, 84 × 120". Collection of Michael Loya

Page 6. *Perla's Reflection*. 2014. Acrylic on magazine, 11 × 8½". Collection of Greg Karns

Page 7. *Maria's Paycheck*. 2013. Acrylic on magazine, 11 × 8½". Private collection

Page 19. *Mulholland Drive: On the Road to David's Studio (after David Hockney's* Mulholland Drive: The Road to the Studio, *1980)*. 2015. Acrylic on postcard. Private collection

Page 20 top left. Pablo Picasso. *The Dead Woman*. 1903. Oil on canvas, 17½ × 13½". Museu Picasso, Barcelona. © 2015 Estate of Pablo Picasso / Artists Rights Society (ARS), New York

Page 20 top right. Pablo Picasso. *Las Meninas*. 1957. Oil on canvas, 76½ × 102½". Museu Picasso, Barcelona. © 2015 Estate of Pablo Picasso / Artists Rights Society (ARS), New York

Page 20 bottom left. Pablo Picasso. *Humorous Composition: Portrait of Jaume Sabartés and Esther Williams, Cannes, May 23, 1957*. 1957. Museu Picasso, Gift of Jaume Sabartés. © 2015 Estate of Pablo Picasso / Artists Rights Society (ARS), New York

Page 20 bottom right. Diego Velázquez. *Las Meninas*. 1656. Oil on canvas, 125 × 108½". Museo Nacional del Prado, Madrid

Page 31 top right. *Azul*. 2015. Archival pigment print on DisplayTrans backlight media in lightbox, edition of 5, 11⅝ × 9⅝"

Page 34. David Hockney. *A Bigger Splash*. 1967. Acrylic on canvas, 96 × 96" Collection Tate, London. © David Hockney

Page 35. *No Splash (after David Hockney's* A Bigger Splash, *1967)*. 2013. Acrylic on canvas, 96 × 96". Collection Museum of Contemporary Art San Diego. Museum purchase, International and Contemporary Collectors Funds

Page 36. David Hockney. *Beverly Hills Housewife*. 1966–1967. Acrylic on canvas, 72 × 144". © David Hockney

Page 37. *Beverly Hills Housekeeper (after David Hockney's* Beverly Hills Housewife, *1966)*. 2014. Acrylic on canvas, 72 × 144". Collection of Seán and Tamara McCarthy

Page 38. *Portrait of a Pool Cleaner (after David Hockney's* Portrait of Nick Wilder, *1966)*. 2014. Acrylic on canvas, 72 × 72". Collection of Miguel Loya

Page 39. David Hockney. *Portrait of Nick Wilder*. 1966. Acrylic on canvas, 72 × 72". © David Hockney

Page 40. David Hockney. *A Neat Lawn*. 1967. Acrylic on canvas, 96 × 96". © David Hockney

Page 41. *The Maintenance of a Neat Lawn (after David Hockney's* A Neat Lawn, *1966)*. 2014. Acrylic on canvas, 96 × 96". Private collection

Page 42. *The Lawn Maintenance (after David Hockney's* A Lawn Sprinkler, *1967)*. 2014. Acrylic on canvas, 48 × 48". Collection of Greg Kucera and Larry Yocom, Seattle

Page 43. David Hockney. *A Lawn Sprinkler*. 1967. Acrylic on canvas, 48 × 48". Collection Museum of Contemporary Art, Tokyo. © David Hockney

Page 44. David Hockney. *A Lawn Being Sprinkled*. 1967. Acrylic on canvas, 60 × 60". © David Hockney

Page 45. *A Lawn Being Mowed (after David Hockney's* A Lawn Being Sprinkled, *1967)*. 2013. Acrylic on canvas, 36 × 36". Collection of Lynda and Stewart Resnick, Los Angeles

Page 46. *Woman Cleaning Shower in Beverly Hills (after David Hockney's* Man Taking Shower in Beverly Hills, *1964)*. 2014. Acrylic on canvas, 36 × 36". Private collection, Washington, D.C.

Page 47. David Hockney. *Man in Shower in Beverly Hills*. 1964. Acrylic on canvas, 65½ × 65½". Collection Tate, London. © David Hockney

Page 48 left. *A Woman Heading to Work, Wilshire Blvd. (after David Hockney's* Wilshire Blvd. Los Angeles, *1964)*. 2014. Acrylic on canvas, 36 × 24". Collection of Ellen Susman

Page 48 right. *A Man Heading to Work, Olympic Blvd. (after David Hockney's* Olympic Blvd. Los Angeles, *1964)*. 2014. Acrylic on canvas, 36 × 24". Collection of Michael Randman

Page 49 top. *Domestic Scene, Hollywood (after David Hockney's* Domestic Scene, Broadchalke, Wilts., *1963)*. 2014. Acrylic on canvas, 36 × 36". Private collection

Page 49 bottom. *No Little Splash*. 2014. Acrylic on canvas, 16 × 20". Collection of Ron Casentini

Page 78. *Self-Portrait*. 2013. Acrylic on magazine, 11 × 8½". Duron Family Collection

Page 79. *Estela and Dylan*. 2013. Acrylic on magazine, 11 × 8½". Collection of Anne Hess

Page 80. *Heracio*. 2014. Acrylic on magazine, 11 × 8½". Collection of Michael Loya

Page 81. *Esperanza Making the Bed*. 2014. Acrylic on magazine, 11 × 8½". Collection of Daniel Rechtstaffen

Page 82. *Rosalia at Naptime*. 2015. Acrylic on magazine, 11 × 8½". Collection of Marlene Nathan Meyerson

Page 83 left. *Esperanza at the Changing Table*. 2014. Acrylic on magazine, 11 × 8½". Private collection

Page 83 right. *Flor in Landon's Room*. 2014. Acrylic on magazine, 11 × 8½". Private collection

Page 84 top left. *Antonia Waiting for Her Check*. 2013. Acrylic on magazine, 11 × 8½". Private collection, Washington, D.C.

Page 84 top right. *Carmen Waiting for Her Check*. 2013. Acrylic on magazine, 11 × 8½". Private collection, Los Angeles

Page 84 bottom left. *Maria Waiting for Her Check*. 2013. Acrylic on magazine, 11 × 8½". Collection of Andrew Mandic

Page 85. *Erizalda Resting*. 2014. Acrylic on magazine, 11 × 8½". Private collection

Page 86. *Laundry Day*. 2014. Acrylic on magazine, 11 × 8½". Collection of Anne Lyons

Page 87 top left. *Misael Waiting for His Check*. 2013. Acrylic on magazine, 11 × 8½". Collection of Alfred Fraijo Jr. and Arturo Becerra

Page 87 top right. *Grizelda Takes a Break*. 2013. Acrylic on magazine, 9 × 8¼". Collection Museum of Contemporary Art San Diego. Museum purchase with proceeds from the Museum of Contemporary Art San Diego Biennial Art Auction 2012

Page 87 bottom. *Miriam's Reflection (The New Gilded Age)*. 2013. Acrylic on magazine, 11 × 8½". Private collection, Washington, D.C.

Page 88. *Nemesio Napping*. 2014. Acrylic on magazine, 11 × 8½". Collection of David and Suzanne Arch

Page 89 left. *Abelina*. 2014. Acrylic on magazine, 11 × 8½". Collection of Lawrence Weschler

Page 89 right. *Two Day Laborers Waiting to Be Paid*. 2013. Acrylic on magazine, 11 × 8½". Collection of AG Sucre

Page 90 left. *Eduardo the Day Laborer*. 2013. Acrylic on magazine, 11 × 8½". Private collection

Page 90 right. *Lupe Setting the Table*. 2014. Acrylic on magazine, 11 × 8½". Collection of Stephen Reily and Emily Bingham

Page 91. *Hilario on the Hillside*. 2014. Acrylic on magazine, 11 × 8½". Private collection

Page 92 top left. *Citlali*. 2014. Acrylic on magazine, 11 × 8½". Collection of Randy Shull and Hedy Fischer

Page 92 top right. *Wilma and Landon*. 2013. Acrylic on magazine, 11 × 8½". Collection MOLAA, Long Beach, California

Page 92 bottom. *Hilario and Hector Waiting for Their Check*. 2013. Acrylic on magazine, 11 × 8½". Collection Cornell Fine Arts Museum, Winter Park, Florida

Page 93 top left. *Lightness and Heaviness*. 2013. Acrylic on magazine, 11 × 8½". Collection of Joel Sweeney and Rocio Rangel

Page 93 top right. *The Grape Pickers*. 2014. Acrylic on magazine, 11 × 8½". 2014. Collection MOLAA, Long Beach, California

Page 93 bottom. *The Next Generation Escalade*. 2014. Acrylic on magazine, 11 × 8½". Collection of Ann and Bob Myers

Pages 94–95. *DVF*. 2015. Acrylic on magazine, 11 × 17". Collection of Charlie James

Page 96. *Macario Disappearing*. 2014. Acrylic on magazine, 11 × 8½". Collection of Susan Curry

Page 98. *Instructions for Leticia*. 2013. Acrylic, ink, and crayon on panel, 22 × 15". Private collection

Page 99 top left. *Directions for Candelario*. 2013. Acrylic, ink, and crayon on panel, 22 × 15". Collection of Marlene Nathan Meyerson

Page 99 top right. *Instructions for Delia*. 2013. Acrylic, ink, and crayon on panel, 22 × 15". Collection of David Schoenthal

Page 99 bottom. *Instructions for Elodia*. 2013. Acrylic, ink, and crayon on panel, 22 × 15". Private collection

Page 100 top left. *Abstract Painting*. 2015. Acrylic on archival pigment print on paper, 54 × 42". Collection of David and Zane Stern

Page 100 bottom left. *Energy and Soul*. 2015. Acrylic on archival pigment print on paper, 54 × 42". Private collection

Page 100 right. *Mexico*. 2014. Acrylic on archival pigment print on paper, 54 × 42". Collection of Morton H. Meyerson

Page 101. *Working for the Weekend*. 2014. Acrylic on archival pigment print on paper, 54 × 42". Collection of Lisa and Jordan Bender

Page 102. *View (Shovel)*. 2015. Acrylic on archival pigment print on paper, 54 × 42". Private collection

Page 103 left. *All About Family*. 2014. Acrylic on archival pigment print on paper, 54 × 42". Collection of Julie and Jim Taylor, theartaffair.com

Page 103 top right. *Grand Revival*. 2014. Acrylic on archival pigment print on paper, 54 × 42". Collection of Thomas Morrison

Page 103 bottom right. *Valentin Cleaning the Pool*. 2014. Acrylic on archival pigment print on paper, 54 × 42". Private collection

Page 104. *The Custodian Is Present*. 2014. Acrylic on magazine, 11 × 8½". Private collection

Page 105 top. *Fritsch Koons Ray*. 2015. Acrylic on magazine, 11 × 20". 2015. Collection of Danni Pascuma

Page 105 bottom left. *Carmen and Her Husband, Teofilo, with Hudson*. 2014. Acrylic on magazine, 11 × 8½". Collection of Ann and Bob Myers

Page 105 bottom right. *Claudia Cleaning*. 2014. Acrylic on magazine, 11 × 8½". Collection of Patsy Marino

Page 106 top left. *Benjamin and Adela in the Jeff Koons Exhibition*. 2014. Acrylic on magazine, 11 × 8½". Collection of Danni Pascuma

Page 106 top right. *Mario Sweeping in the Jeff Koons Exhibition*. 2014. Acrylic on magazine, 11 × 8½". Collection of Kim and Larry Heyman

Page 106 bottom. *Carmelina Cleaning in the Jeff Koons Exhibition*. 2014. Acrylic on magazine, 11 × 17". Private collection, Washington, D.C.

Page 107. *La Limpieza*. 2014. Acrylic on magazine, 11 × 8½". Collection of Todd and Jennifer Klawin, Manhattan Beach, California

Page 108 left. *Heriberto Cleaning*. 2014. Acrylic on magazine, 11 × 8½". Collection of Afrooz Family

Page 108 right. *Martin Sweeping*. 2014. Acrylic on magazine, 11 × 8½". Collection MOLAA, Long Beach, California

Page 109 left. *Juan*. 2014. Acrylic on magazine, 11 × 8½". Collection MOLAA, Long Beach, California

Page 109 right. *Yadira and Greyson in the Gallery*. 2014. Acrylic on magazine, 11 × 8½". Collection of Susan and Richard Ulevitch

Page 110. *Refugio*. 2014. Acrylic on magazine, 11 × 8½". Collection of David and Suzanne Arch

Page 111. *Genaro and Jacinto*. 2014. Acrylic on magazine, 11 × 8½". Collection MOLAA, Long Beach

Page 112 top. *Soledad*. 2014. Acrylic on postcard, 7 × 5"

Page 112 bottom. *Janitor Walking in Front of Matisse's La Gerbe*. 2014. Acrylic on postcard, 5 × 7"

Page 113 top. *Woman Cleaning (after David Hockney's Studio Hollywood Hills House)*. 2014. Acrylic on postcard, 5 × 7"

Page 113 bottom. *Woman Waiting (after David Hockney's Invented Man Revealing Still Life)*. 2014. Acrylic on postcard, 7 × 5"

Page 114 top. *Custodians near Urban Light, LACMA*. 2014. Acrylic on postcard, 5 × 7"

Page 114 bottom. *Custodians, LACMA*. 2014. Acrylic on postcard, 7 × 5"

Page 115. *Janitor Under Levitated Mass, LACMA*. 2014. Acrylic on postcard, 7 × 5"

Page 118 top left: *Noelia cleaning (after Roy Lichtenstein*, Wallpaper with Blue Floor Interior*)*. 2015. Archival pigment print on DisplayTrans backlight media in lightbox, edition of 5, 11⅝ × 16¾"

Page 118 bottom. *Clara Cleaning (after Jeff Koons* New Hoover Convertibles, New Shelton Wet/Drys 5-Gallon Double Decker*)*. 2015. Archival pigment print on DisplayTrans backlight media in lightbox, edition of 5, 11⅝ × 9⅝"

Page 121. Luis Jimenez. *Border Crossing/Cruzando El Rio Bravo*. 1989. Fiberglass with acrylic urethane finish, edition 4 of 5, 2 A.P.s. 127 × 54 × 34". Collection Museum of Contemporary Art San Diego and San Diego Museum of Art in honor of Jackie and Rea Axline. © 2015 Estate of Luis A. Jimenez, Jr. / Artists Rights Society (ARS), New York

Page 122. Ester Hernandez. *Sun Mad II*. 1981. Screen print on archival paper, #37/53. 26 × 20". Collection Museum of Contemporary Art San Diego. Museum purchase. © 1981 Ester Hernandez

Photo Credits

David Feldman: 18, 22 right, 27, 55 all, 56 all, 57 all, 60, 62, 64, 66, 70 top, 71, 73, 75 all, 76–77.

Ramiro Gomez: 58, 59 all, 61, 63, 65, 67, 68 all, 69 all, 70 bottom, 72. Sarah Nesbitt: 116 all, 117 top.

Osceola Refetoff: 45, 46, 49 top.

Richard Schmidt: 4, 36.

Philipp Scholz Rittermann: 35.

RCH/EKH: 5, 41, 103 bottom.

Benjamin Thacker: 103 left, 103 top right.

Michael Underwood: 30 top right, 37, 38, 42, 48 left, 48 right, 49 bottom, 100 all, 101, 104 top, 118 top left, 118 bottom.

Lawrence Weschler: 15 both, 16 both, 25 all, 26 both, 28 both, 30 both, 31 bottom left.

Acknowledgments

The artist would like to convey his sincere and heartfelt thanks to the following people for their contributions to the production of this book: David, my family, Charlie James, Rachel Cohen, Dane Johnson, Cris Scorza, Eric Himmel and the entire team at Abrams Books, Ren, Gregory Evans, and David Hockney.

With the greater part of which the principal author wholeheartedly concurs, adding a particular note of appreciation to three of his own longtime political muses: Michele Prichard, Diane Factor, and Rhoda Rosen.

Ramiro Gomez and Lawrence Weschler

Editor: Eric Himmel
Designer: Devin Grosz
Production Manager: Anet Sirna-Bruder

Library of Congress Control Number: 2015949560

ISBN: 978-1-4197-2069-7

Introduction © 2016 Lawrence Weschler
Afterword © 2016 Cristina Scorza
Works by Ramiro Gomez © 2016 Ramiro Gomez

Printed and bound in Italy
10 9 8 7 6 5 4 3 2 1

Abrams books are available at special discounts when purchased in quantity for
premiums and promotions as well as fundraising or educational use. Special editions can
also be created to specification. For details, contact specialsales@abramsbooks.com or
the address below.

THE ART OF BOOKS SINCE 1949

115 West 18th Street
New York, NY 10011
www.abramsbooks.com

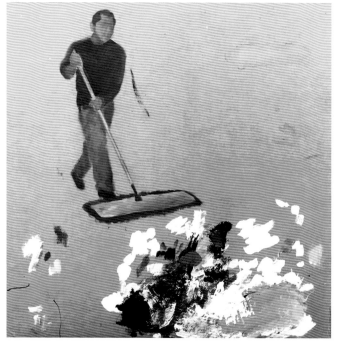

The Cleanup, 2015